EXPANDING YOUR SLR SYSTEM

Consultant Editor David Kilpatrick

Collins

CONTENTS

Published in 1981 by
William Collins Sons & Co Ltd
London · Glasgow · Sydney ·
Auckland · Johannesburg

Designed and produced for
William Collins Sons & Co Ltd
by Eaglemoss Publications Limited

First published in *You and Your Camera*
© 1981 by Eaglemoss Publications Limited

ISBN 0 00 411685 2

Printed in Great Britain

INTRODUCTION

One of the main attractions of the 35mm SLR camera is its versatility. Combined with the right accessories you can use it for most picture-making situations. *Expanding Your SLR System* opens up this world of camera accessories from simple inexpensive filters to sophisticated zoom lenses, mirror lenses and autowinders.

To build up a worthwhile system you need to select those items most suited to the sort of photographs you take. But there are so many alternatives that, without expert guidance, choosing even the simplest accessory can be confusing. For example, for your indoor photography do you really need an automatic flashgun or would a manual flashgun answer your needs? Do you take enough long distance photographs to justify a telephoto lens? Perhaps a less expensive teleconverter or versatile zoom lens would be a better buy? This book sets out to simplify your choice by outlining the range of available equipment and what it is best used for.

On the practical side, first-class photographers illustrate the creative potential of filters, lenses, special effects equipment, autowinders and studio lighting. Diagrams, comparative photographs and text combine to show you how the equipment works and how to use it like a professional.

Choosing a 35mm SLR camera

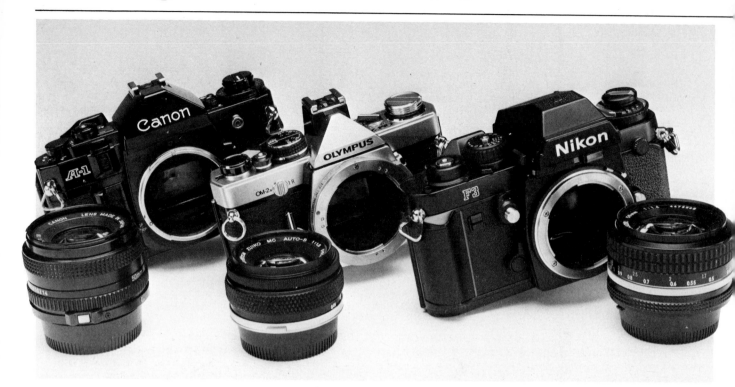

With its accurate viewing and focusing system, through–the–lens (TTL) metering, and interchangeable lens facility providing scope for almost every picture–taking situation, it is easy to see why the 35mm SLR is a popular general purpose camera. There is a vast number to choose from, and the competition in terms of specification, quality and price is keen.

There are a number of points to consider before spending your money.
● What is the most you can afford to spend?
● What type of exposure metering do you want?
● Is the viewfinder easy to use?
● Are the controls convenient?
● Are the shutter speed and aperture ranges adequate for your purposes?
● Does the camera allow you to build up a worthwhile system (particularly lenses)?

Price

Decide on your price limit, and stick to it. Only you can know how much you can afford to spend, not the person from whom you are buying. It is worthwhile spending an hour or so scanning through dealers' advertisements to see how much prices vary for the camera you would like to buy. Remember that the price of a camera often reflects the price of accessories you will want to add later. Try to think ahead; can you afford a system?

Exposure measurement

Almost all SLRs today have TTL metering, and light readings are taken from light passed by any focal length lens. (External or hand–held meters can be time–consuming to use.)

A full aperture metering camera can take light readings with the lens set at its widest aperture. The viewfinder therefore remains bright for ease of focusing and composition, and is closed down to the correct aperture only when the shutter is released.

Stopped–down metering means that an accurate reading can only be taken at the working aperture and, although cheaper, this system is not as convenient to use as is full–aperture metering.

Manual or automatic?

Do you want the built–in meter to give automatic or manual exposure settings? With a manual camera the photographer has to decide on the combination of aperture and shutter speed to provide a correct exposure. This gives the photographer total control, but time can be lost in setting both camera controls. Automatic exposure systems can be far quicker to use.

If you decide to buy one of the many cameras offering automatic exposure setting, consider whether you prefer an aperture priority or shutter priority system. The new multi-mode cameras have a choice of both systems; some can also programme both settings without the photographer having to do anything except set the film speed, compose and focus. Automatic use means that if lighting conditions are constantly changing the exposure is instantly and automatically adjusted.

Viewfinder

The SLR is built around its viewing system, so the viewfinder is an important feature. A large rearsight enables spectacle wearers to see the whole screen clearly—if a rubber eye cup can be fitted this is often more comfortable to use.

Focusing screens vary in construction, some being brighter and more evenly illuminated than others. Dim, uneven focusing screens can hamper accurate focusing.

A few cameras have interchangeable screens and viewfinders, but most people can manage quite happily with the ground–glass screen, microprism circle and split image centre spot commonly seen in many modern SLR cameras.

Also often shown in the viewfinder are the shutter speed, lens aperture, or both. Over– and under–exposure warnings and correct exposure signals are almost always featured. Such complete viewfinder information shows the exposure situation at a glance.

Some manual cameras only have a

▲ The 42mm screw thread lens mount is now usually only found on cheaper manual cameras. To ensure correct focus the lens must be completely screwed in. Changing screw-in lenses can be time-consuming.

▲ Many cameras in all price ranges have bayonet lenses. First align the two reference dots: three claws on the lens then mate with three slots in the camera mount. A short twist locks in the lens for full exposure coupling.

▲ ▶ Metering at full aperture ensures a bright viewing image whatever aperture is set, but depth of field is difficult to judge without a preview.

▲ ▶ Stopped-down meter readings always darken the viewfinder image according to the aperture set; depth of field can be seen but focusing may be difficult.

◀ Whether you choose full-aperture or stopped-down metering, exposure results should be identical. Decide if you want economy or convenience.

correct exposure indication, with no other exposure information provided. This system demands that you know the camera well enough to judge which shutter speed and aperture you have set without removing your eye from the eyepiece.

Pointer needle meter displays can often be interpreted more accurately than light emitting diodes (LEDs), so that with experience you can deliberately make small exposure adjustments, perhaps only ⅓ stop, without looking at the aperture or shutter speed dials. Black needles can, however, be much more difficult to see than LEDs in dim light, or against a dark subject area.

Handling

Once you have decided on the type of camera you would like to buy by checking price and specification, you will probably have a short–list of two or three different cameras. From then on your choice becomes far more subjective, and you can only make your final decision based on how you feel about the handling of each camera.

Size, bulk, weight and layout of controls are all matters of personal preference. Some people prefer a shutter

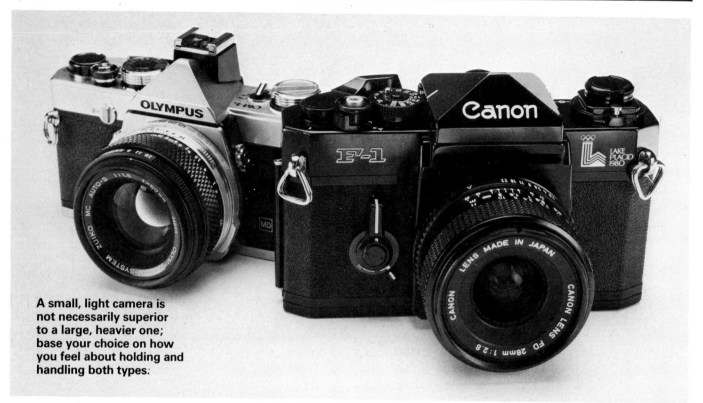

A small, light camera is not necessarily superior to a large, heavier one; base your choice on how you feel about holding and handling both types.

speed dial to be on the camera top plate, for example, whereas others like a shutter speed ring to be around the lens mount. Both types are available.

A bright viewfinder and ease of fine focusing are equally important—but you can only judge if these aspects are up to your standards by going to a dealer and handling a number of cameras.

Spend a little time with each of your short–listed cameras in your hands to feel how the film advance lever, aperture and shutter speed controls, automatic and manual metering, and depth of field preview operate.

Shutter

If you take action pictures the camera's fastest shutter speed is important. Top speeds of 1/1000 (more rarely 1/2000) can freeze fast motion. If much of your photography is in low light then the choice of speeds at the slow end of the range is more important.

Speeds may be controlled electronically or mechanically. Automatic electronic cameras often have a shutter speed range down to 8 or 16 full seconds, and shutter speeds can be infinitely variable (or 'stepless') through the range. If a mechanical speed is also provided (some cameras have more than one) you can make an exposure even if the batteries fail—but

the meter will no longer operate.

Most focal plane shutters synchronize for flash at 1/60 or slower, but some allow use of 1/125 to give more exposure choice when you use fill–in flash.

Noise and vibration are important considerations, especially to the wildlife or candid photographer, and lack of vibration is especially important when using slow speeds or telephoto lenses.

Powered film advance imposes extra strain on mechanical shutters and mirror movements, and cameras have to be constructed more robustly to cope with this. While most bodies are robust enough to cope with the modest 2fps rate of an autowind, stronger construction is needed for the more rapid shooting rates required by motor–drives. Go on brand reputation and whether the main body and controls have a substantial feel to them.

Lenses

The majority of 35mm SLR cameras have bayonet fitting lenses. Few now retain the once universal 42mm screw thread because, although the lenses tend to be slightly cheaper, it takes longer to unscrew one lens and screw in another than the more rapid twist–lock bayonet action.

Bayonet fittings for different camera brands vary, and specific types are

rarely (if ever) interchangeable between different makes of camera. The major exception is the Pentax-K bayonet design from Asahi which is now featured on several other camera names. There are also ranges of lenses by independent manufacturers made to fit cameras of varying bayonet designs. You almost always have to buy a camera with its standard lens. This is often 50 or 55mm in focal length, but 40 and 45mm standard lenses with their slightly wide angle view are gaining in popularity.

Common maximum apertures, in order of cost, are f1·2, f1·4, f1·8 and f2. A wide maximum aperture gives a slight exposure edge in dim light, but you may prefer to use a fast film than to buy a more expensive lens which, in practical terms, can only give perhaps an extra half stop.

Lenses often sell on reputation—but for good reasons. It is therefore better to go for well–known makes when choosing lenses rather than the cheapest one you can find. Take bulk and weight into account when buying additional lenses—both should complement the camera body.

If you aren't obliged to buy the standard lens with the camera body, consider buying a zoom which takes the 50mm focal length in to its focal length range. It will doubtless cost more than a

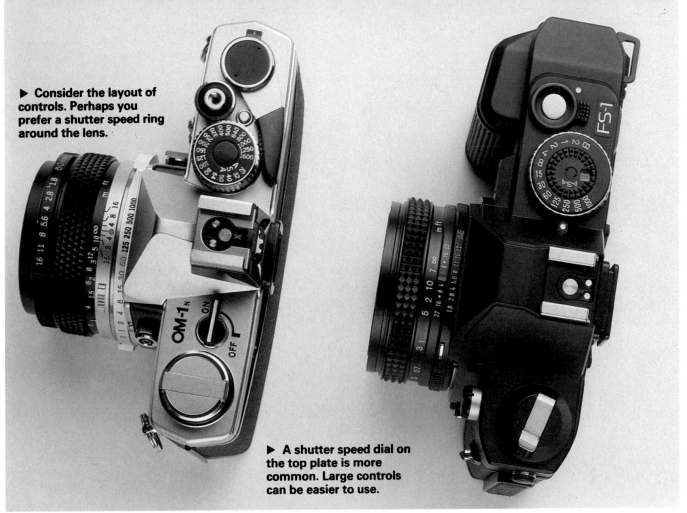

▶ Consider the layout of controls. Perhaps you prefer a shutter speed ring around the lens.

▶ A shutter speed dial on the top plate is more common. Large controls can be easier to use.

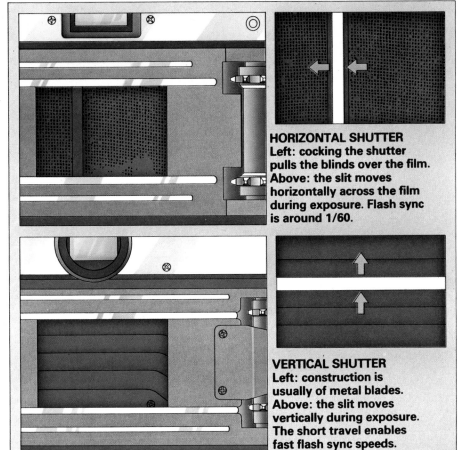

HORIZONTAL SHUTTER
Left: cocking the shutter pulls the blinds over the film. Above: the slit moves horizontally across the film during exposure. Flash sync is around 1/60.

VERTICAL SHUTTER
Left: construction is usually of metal blades. Above: the slit moves vertically during exposure. The short travel enables fast flash sync speeds.

standard lens, but by no means as much as several lenses encompassed by the zoom range.

Choosing

Consider first that the camera will be the heart of your outfit, so ensure a good range of reasonably priced lenses and accessories are readily available from the manufacturer and from independent makers. Even more important, make sure that the camera suits your requirements, that it is comfortable to hold, and that the controls are of a suitable size with clear lettering where applicable.

Operation should be easy, not a task. Don't be too influenced by flashing coloured lights, bleeping signals, and a 'professional' finish. These can be useful, but none of them make better pictures. Remember that the more LEDs there are, the greater the drain on the batteries—batteries can be expensive.

Bargains can often be had by buying a second-hand camera. Many dealers offer discount on new equipment and this can provide a useful saving. In any event, don't expect to combine the maximum discount with the maximum of after-sales service. It is rarely possible, and your dealer's advice as you progress is usually worth your paying that little extra.

Building up an SLR outfit

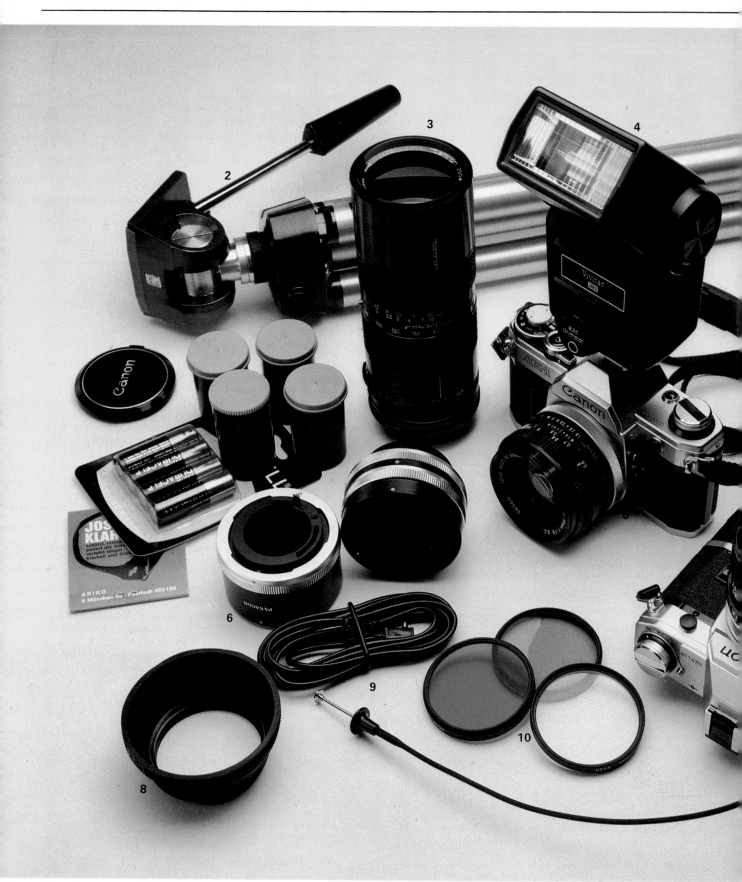

The biggest attraction of a 35mm single lens reflex camera is its versatility. Not only is it a useful piece of equipment in its own right, but it can be the 'heart' of a complete camera outfit. You can add things like extra lenses, filters, a flashgun, a tripod, as and when you feel you need them, to help you get the results you want.

Smaller items—a blower brush for cleaning lenses, or a cable release, for example—also form part of the serious photographer's equipment as the collection builds up. And, of course, you will need a gadget bag, or a carrying case to keep everything in.

The right priorities

Don't be put off by the vast array of camera accessories on the market—you won't need them all. Obviously you need to sort out priorities and decide what to buy now and what to leave for later. This will mainly depend on:
• Your style of photography. Think about the items you really need to help with the type of photography you concentrate on, be it landscapes, portraits, still life or sport.
• Your budget. A cheaper item, such as a filter, can open up new fields, even if you can't yet afford to invest in more expensive extra lenses.

Inexpensive basics

First, think about the smaller items for the outfit. *A lens hood* (rubber or metal) not only protects the front of the lens from damage but helps to prevent 'flare' when shooting towards the sun. Camera shake can be a problem, so *a cable release* is useful whenever long exposure times require

◄ **An ideal basic outfit ? This is the range of equipment many keen amateurs might hope to own after two years or so.**
1 **Gadget bag**
2 **Collapsible tripod**
3 **80–200 zoom lens with macro focusing**
4 **Electronic flashgun**
5 **Camera body with 50mm lens**
6 **Extension tubes**
7 **Second camera body with 24mm lens, motorwind, and cable release**
8 **Rubber lens hood**
9 **Flash extension lead**
10 **Selection of filters**
Additional items shown are films, batteries, a lens cap, and cleaning tissues. You might also carry a notebook and pencil, a puffer brush, and a small screwdriver set.

the camera to be mounted on to a tripod or support. Camera care equipment, such as *a blower brush, lens cleaning tissue* and even a small screwdriver set for on-the-spot repairs (a loose screw on the lens, for instance) all have a place in the outfit too.

Camera bags

You will need some sort of carrying bag for these first basic accessories. At first a medium-sized soft shoulder bag is enough to carry the camera, lens hood and filter, spare film, lens cleaning tissues and hand-held exposure meter—if your camera has no TTL metering. It is helpful if the bag has an outside pocket of some sort to keep the small items from getting damaged by the bulkier ones. Just make sure the various things are well wrapped in dusters to stop them banging about.

Some people keep their camera in its ever-ready case.

As you add more items to your outfit a special camera carrying case is more suitable. Most are made from reinforced real or simulated leather, and contain cut-outs or removable inserts to secure various pieces of equipment. Most have carrying handles as well as shoulder straps, so that the case can be carried easily while you are taking photographs.

There are various ways you can make sure your equipment is securely held in the case, and overleaf we show how a typical camera bag can be adapted to your precise needs.

Finally, and very much for the larger outfit, there is a range of more expensive aluminium attaché cases with foam rubber inside, which can be cut to hold the equipment firmly. These offer good protection, but they can be the most expensive. Avoid the cheaper ones made of foil-covered plywood which is lighter, but does not offer as much protection. Bear in mind that, because these aluminium cases are brightly finished, they tend to be conspicuous—and may possibly attract a thief.

Choosing filters

There are many different types of filter on the market, but the basic outfit need only contain four or five. Most photographers start off with a simple skylight 1A filter which cuts through ultra violet 'haze'. Unlike a normal UV filter, it is also colour corrected, so it can be used for black and white *or* colour film. The skylight filter can be kept on the camera all

the time to stop dust and dirt spoiling the lens.

A polarizing filter will counteract reflections from glass or other similar surfaces, darken the sky, and make colours more vivid.

Various coloured filters—red, green, blue, yellow—can be used for effect in black and white work. In a landscape shot, for instance, a yellow filter will make the sky darker, an orange filter will exaggerate the effect, while a red filter darkens the sky still further. With colour film, these filters give an overall colour cast to the picture, which can be effective.

Colour correction filters are useful for either colour negative or transparency film. They enable you to take daylight pictures with tungsten (artificial light) film, and vice versa.

So a few filters will make a worthwhile yet reasonably inexpensive addition to your camera outfit. You might want one or two of the simpler special effects filters, as well. The starburst turns a single light source into a repeated star shape, and a soft focus filter can be used to soften portraits.

Lenses

The most important additions to the camera outfit are the extra lenses. If you have always used a standard lens on your camera, you may not find it easy to decide which would be the best lens to buy next. Obviously, you want to start with the one that will be the most versatile for your type of photography. As a first buy, most photographers choose a wide angle lens (28mm) or a telephoto lens (135mm). If you like taking scenic landscape pictures or you want to include a wide area without having to step back with the camera too much, then a wide-angle lens is a good choice. A 28mm lens is the most popular type of wide angle. Lenses of 24mm and wider give more image distortion and can give an interesting special effect but, with care, they can also be of general use. For portraits, sport and other general types of photography, buy a 135mm telephoto lens. Most of them are lightweight, easy to use and reasonably priced. Later, you can invest in a longer focal length lens (200mm or more) for distance shots.

On the other hand, many photographers now buy a zoom lens as an alternative which means that they get, in effect, three or more lenses in one compact unit: which also means there's less weight to carry about. Both wide

angle to normal (28–50mm) and short-telephoto to long-telephoto (80-210mm) zoom types are available, and some even offer a close-up, 'macro', setting. A zoom lens may well be cheaper than a set of three or four lenses of fixed focal length.

Some independent lens manufacturers make interchangeable mounts so that, if you decide to change your camera later on, you can keep your lenses and simply buy another mount.

Camera supports

A tripod, or a similar form of camera support, is essential for any long exposure shots. There are many tripods on the market, from table-top models to heavy-duty studio stands. Look for one which is sturdy but lightweight and portable (most are made of aluminium). Quick release legs and an adjustable pan and tilt head are useful features. Simpler and more portable camera supports include a monopod (a single leg tripod) or a G-clamp, which attaches to a table or similar surface and has a tripod screw to support the camera in any position.

Looking ahead

As your photography develops you may want to add items such as a flashgun for indoor photography or fill-in lighting outdoors, or perhaps a motor-drive for fast action photo-

graphy, if your camera will accept one. At a later stage, you could get an extra camera body, so that you can shoot black and white and colour at the same time, or use two different lenses without having to keep changing them. But remember to buy only the items that you will really need, otherwise you could end up with a gadget bag full of expensive hardware which you never use.

Hiring equipment

It is always worth discussing with your local photographic dealer the possibility of hiring certain items—either for very occasional use, or before you decide to buy. You may feel that the high cost of a long telephoto lens or a more powerful flash unit would not be justified by the number of times you would use it.

Insurance

Once you start accumulating valuable equipment, it is wise to consider insuring it all. Although there are separate policies for camera equipment, most companies advise amateurs to add their equipment on to an existing household contents policy. With an 'all risks' extension, the equipment should be covered for accidental loss or damage, even on location. But check with your insurance company, or a broker, for more details.

Equipment to buy for . . .			
Subject	**Lenses**	**Filters**	**Other items**
Landscapes	Any wide angle (24–35mm) Telephoto (100–200mm)	Skylight 1A Polarizing Coloured (red, yellow, green etc)	Tripod Cable release
Portraiture	Telephoto (85–105mm) Short tele-zoom (70–150mm or similar)	Skylight 1A Colour conversion (80A or 85B) Simple effects (starburst or soft focus)	Tripod Cable release Flashgun
Still life	Lens with macro facility (usually zoom or telephoto)	Skylight 1A Polarizing Colour conversion (80A or 85B)	Tripod Cable release Screw-on close-up lenses Flash gun
Sport	Telephoto (135mm or 200mm) Long zoom (70–210mm, 100–300mm or similar)	Skylight 1A Polarizing Coloured (red, green, yellow etc)	Shoulder or hand grip (with build-in cable release) Autowinder or Motordrive

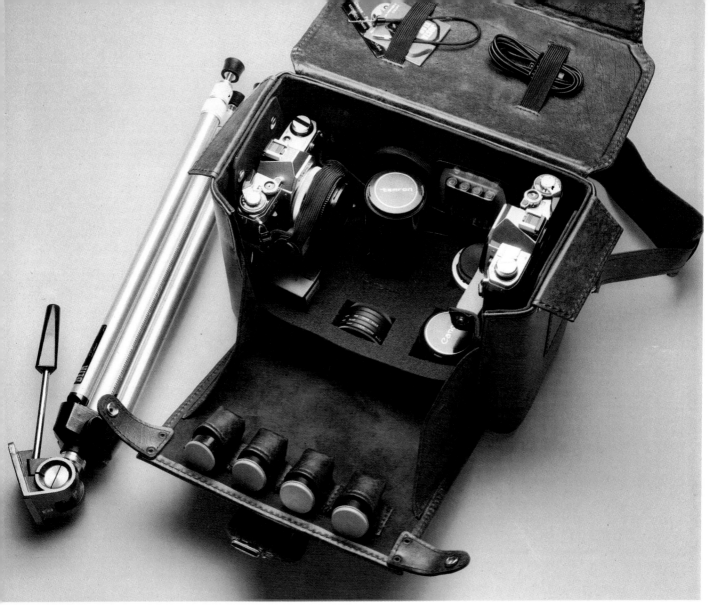

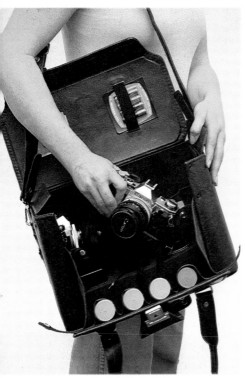

▲ All the equipment shown on the previous spread packs neatly into this Bush & Meissner gadget bag with room to spare for further additions. But lenses and other expensive items could be damaged by knocking into each other so it is worth making a foam base for the bag, tailored to fit each piece of equipment. Adapting a bag in this way is easy and cheap.

Buy a piece of plastic foam 7–8cm thick and trim it to fit tightly into the bottom of your bag; then follow the instructions set out on the right. Take care, when you plan the layout, that larger objects do not obstruct built-in pockets already in the bag. If you need to add an extra piece, stick the foam with any all-purpose household glue.

◀ Keep at least one camera body loaded with film and with a lens attached, so it is always ready to use. The extra front flap on this bag means you can get at all your equipment quickly.

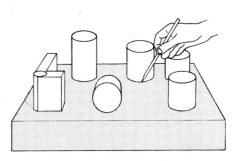

▲ Arrange equipment carefully on top of the foam base and trace round each item with a felt pen.

▲ With a craft knife, cut the foam round the lines marked and remove to leave storage spaces.

Controlling colour with filters

Whether you viewed this page outside in strong sunlight, by candlelight or light from tungsten lamps, your eyes would still see it as white. But, in fact, light from these and other sources varies widely in colour quality: candlelight has a high red content, sunlight is much bluer. Even though your eyes can adapt to different light sources, colour films cannot.

Colour slide films are balanced to reproduce colours accurately with one specific light source. As it is impractical to manufacture a large number of films for use in every possible type of light

the main choices are daylight or tungsten balanced films. But it is only common sense that you should be able to use your films with other types of light. Special filters have been designed for use over the camera lens to provide either a substantial or a subtle change in the quality of the light reaching the film, thereby accurately reproducing the original subject colours.

With colour negative films minor adjustments can be made in the overall print colour by changes in filtration at the printing stage. With colour slide film you only need to use colour filters if the

result is likely to be unacceptable—such as to eliminate a blue cast when using tungsten film in daylight. You might, for example, decide to use daylight slide film in tungsten lighting to give a warm glow to a cottage interior. Much depends on the atmosphere you want to create—using a red filter to warm the tones of a snow scene would completely lose the feeling of coldness.

Colour temperature

One of the ways of expressing the colour quality of a light source is as a colour temperature which is measured in

HOW LIGHT QUALITY CHANGES THROUGH THE DAY

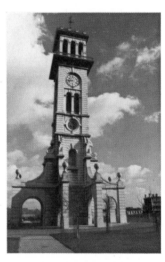

▲ Half an hour before sunset: the building and surroundings are strongly tinged with yellow.

▲ Just before dawn: the sun, just below the horizon, imparts a magenta cast to building and clouds.

▲ Half an hour after dawn: the sun is low in the sky and gives the scene a warm orange cast.

▲ Noon: colours are now neutral (notice the path and the grass). There is a slight blue cast in shade.

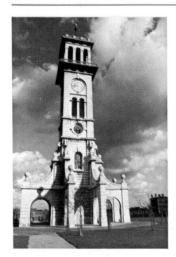
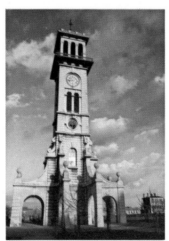
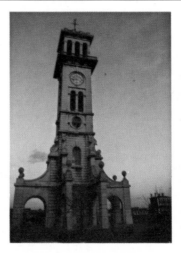

▲ Two hours before sunset: the lower angle of the sun begins to warm the light tones of the building.

▲ Half an hour before dawn: the sky begins to lighten, and the building has a deep purple cast.

▲ At sunset: the sun is on the horizon and the warm cast is much more noticeable—almost red.

▲ Just after sunset: the sun no longer lights the building which becomes magenta in colour.

degrees Kelvin (K). For example, a light source with a high red content, such as a 500W tungsten studio lamp, has a relatively low colour temperature (3200K), whereas sunlight which is rich in blue has a higher colour temperature (5500K).

Colour temperature can be measured with a special colour temperature meter. But for practical purposes all you need to know is that the colour temperature of the light source you are using is approximately the same as that stated on the film carton (see table).

Daylight films produce best colour reproduction in midday sunlight (5500K), whereas tungsten film is designed for use with photographic lamps (3200K). If the light source does not match the colour temperature for which your slide film is balanced an unwanted colour cast may result. In such situations a filter must be used over the camera lens. Choosing the right filter changes the light source to suit the film exactly.

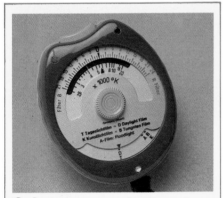

Colour temperature meters

Sometimes it is vital that the precise colour temperature of a light source is known so that accurate colour reproduction is assured by use of the correct filter. Some professionals use a colour temperature meter for this reason.

The cheapest and simplest types measure red and blue light content, while the more expensive ones read green content in addition. You simply point the meter at the light source and read the appropriate correction filter from the meter scale.

Although some makes may be more reliable than others, colour reproduction can be more accurate by this method than by guesswork. The units are, however, expensive and have few advantages in day-to-day photography.

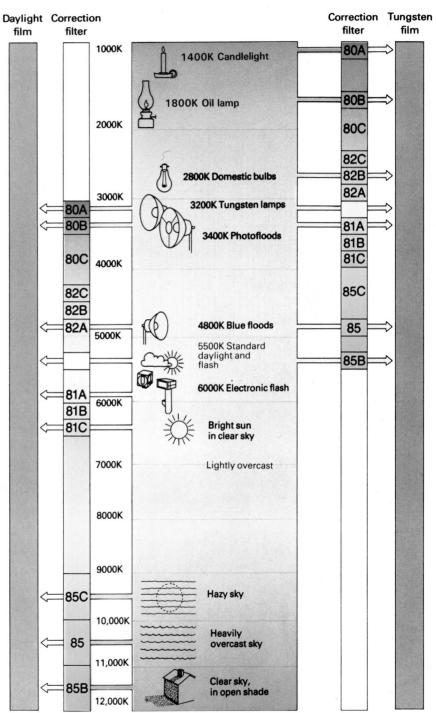

COLOUR TEMPERATURE TABLE
Light source colour quality and appropriate filtration

Daylight film	Correction filter			Correction filter	Tungsten film

1000K
1400K Candlelight — 80A
1800K Oil lamp — 80B
2000K — 80C
— 82C
2800K Domestic bulbs — 82B
— 82A
3000K
80A
80B — 3200K Tungsten lamps — 81A
3400K Photofloods — 81B / 81C
80C — 4000K
85C
82C
82B
82A — 5000K — 4800K Blue floods — 85
5500K Standard daylight and flash — 85B
6000K Electronic flash
81A — 6000K
81B
81C — Bright sun in clear sky
7000K — Lightly overcast
8000K
9000K
85C — Hazy sky
10,000K
85 — Heavily overcast sky
11,000K
85B — Clear sky, in open shade
12,000K

▲ Use this table as a guide to good colour balance with different films and light sources. You won't need all the filters, but choose one or two which are appropriate to your photography. Red or blue content is determined by colour temperature (in degrees Kelvin). Use a blue or red filter accordingly to change the quality of light reaching the film. You can use two filters (of the same colour) for a finer balance.

Filters

There are three basic types of colour correction filters. They differ in type and degree of correction, but are all designed to remove unwanted colour casts. Depending on the density of the filter, some exposure adjustment may be necessary.

Colour conversion filters: These are filters of a fairly strong colour, either blue or orange. They are used mainly when you have the wrong type of film loaded for the particular light source. If you have daylight slide film in the camera and want to take pictures by tungsten light, you must *convert* the quality of the light reaching the film. If you do not, the slides will turn out unacceptably orange in tone. By using a blue filter (Kodak 80A or equivalent) you raise the colour temperature of the tungsten light to suit the daylight balanced film.

Conversely, if you take photographs in daylight with tungsten film in the camera, the slides will look blue and cold in tone. By using an orange filter (85B) the colour temperature of light reaching the film is lowered to give correct colours.

TUNGSTEN FILM IN DAYLIGHT

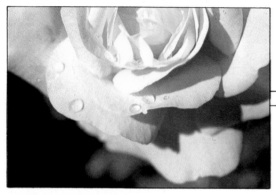

▲ Tungsten film is balanced for use with tungsten lamps (3200K). When used in daylight (5500K) colour photographs are unacceptably blue and cold in tone.

▲ An 85B (orange) colour conversion filter is the correct choice.

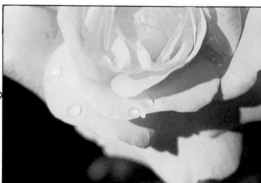

▲ The 85B filter has absorbed much of the blue content of daylight and the cold tones are sufficiently 'warmed' to reproduce the colours of the rose accurately.

Light balancing filters: There are occasions when only minor adjustment in the colour quality is desirable. Light balancing filters are used to obtain a bluer or redder colour picture with a particular light source. When using tungsten film, which is balanced for use with photographic lamps (3200K), with photofloods (3400K), an 81A (pink) filter over the lens lowers the colour temperature by 200K. This produces correct colour balance rather than a slight blue cast which would otherwise result.

An overcast sky has a higher colour temperature than 'average daylight'— perhaps 7000K. On daylight film a cold blue cast may appear unless the colour temperature is lowered sufficiently by using the appropriate 'warm' colour filter.

Light balancing and conversion filters may be used in combination on occasions when an even finer adjustment of colour balance is required, but this is rarely necessary in normal day-to-day photography.

DAYLIGHT FILM USING 100W BULB

▲ Light from a 100W domestic light bulb has a relatively low colour temperature and is therefore rich in red (see table). If you use daylight film in this type of lighting the result will be a deep orange cast.

▲ The 80A filter is deep blue and absorbs much of the red light. An exposure increase is necessary.

▲ Although the tones are not completely corrected by using the 80A filter the colour has lost most of its orange cast and the picture, particularly the skin tones, are much more acceptable.

TUNGSTEN FILM USING 100W BULB

▲ Because tungsten film is balanced for use with tungsten lamps, a 100W bulb gives a warm, slightly orange result. This is not as extreme as when using daylight film.

▲ If you find this slight orange cast unacceptable, use a blue 82B filter.

▲ You can see the effect of the 82B filter clearly in the surrounding white walls and in the skin tones. Colour reproduction is accurate throughout the scene.

DAYLIGHT FILM UNDER OVERCAST SKY

▲ Although your eyes would hardly notice the blue quality of overcast daylight, daylight film registers the high blue content to produce cold tones.

▲ You can use a pink 81A filter to reduce the blue light reaching the film.

▲ The 81C filter is a deeper pink than the 81A and therefore produces accurate colour in overcast conditions. An 81A and 81B combined have the same effect.

DAYLIGHT FILM UNDER CLEAR BLUE SKY

▲ If you looked at this market stall on a cloudless, sunny day the cover would look brilliant white. However, the high colour temperature of a clear blue sky produces a heavy blue colour cast.

▲ An 85 filter (deep orange) can balance colours by absorbing a large proportion of blue light.

▲ Use of an 85 filter has removed much of the blue cast. The areas in shadow, however, remain blue. Using a deeper orange filter would give better colour but the required exposure would be too long.

Colour compensating (CC) filters: The main difference between CC and the other two filter categories is that CC filters are used to make very small changes in the colour balance of pictures.

The range of CC filters consists of six different colours (red, green, blue, cyan, magenta and yellow) in six different densities, available as gelatin squares. In practice the CC filters needed are usually determined by trial.

Photographers often use them to ensure consistent colour results between batches of the same type of colour slide film. The new batch is exposed and processed as normal, and then compared with a selected result from the previous batch. This is done by viewing the slides side by side. The trial slide is viewed through a range of CC filters until the colour balance visually matches that of the control slide. Once the combination of filters which gives a precise match is established, filters of *half* this strength are then used over the camera lens when exposing the new film batch. (Some professional colour films have filter recommendations for that batch printed on the pack.)

To try this on your own films, view your slides under standard viewing conditions without filtration. (Standard in this sense means a consistent light source—preferably a light box with a 'colour matching' fluorescent tube.) Obviously viewing a slide held up to a window will give a different impression to viewing it against a domestic light bulb. If you feel that one slide has a cold bias, view it through a red, magenta or yellow CC filter (or a combination of any two) to determine whether the imbalance is cyan, green or blue. Similarly, view a warm slide through cyan, green or blue filters to find out whether the imbalance is red, magenta or yellow. You will get more accurate results if you correct for the mid-tone areas rather than the highlights. An exposure increase may be necessary.

Colour compensating filters are also used to compensate for deficiencies in the quality of a light source. They can be used to give correct colour balance when taking photographs in fluorescent light. Many photographers use CC filters when taking pictures under water because the red content of light is progressively reduced with increasing depth. You can also use a combination of filters to correct colour imbalance when duplicating slides.

◀ You can buy colour compensating filters in red, green, blue, cyan, magenta and yellow (left to right) for fine colour adjustment. They are available in a range of densities—the examples shown are CC10, which let through 80% of the light.

Reciprocity

When using film at exposure extremes—either very short or very long exposure times—there may be a shift in the film's response to light. Such a shift affects the overall colour of the image. This is known as Reciprocity law failure. Once again, the correct filter can control the colour balance of the slide, enabling the advanced photographer to produce first-class colour slides in adverse conditions.

For example, when Kodachrome 64 is exposed at shutter speeds between 1/10 and 1/1000, no correction is needed. But at 1 second, a colour compensating filter, CC10 red, is required, as well as one stop more exposure. Similarly Kodachrome 25, when exposed for 1 second, needs CC10 magenta filtration and one stop more exposure.

▶ **You will rarely encounter problems with 'reciprocity' unless you use long exposures when the film's response to light causes a slight colour shift.** *Peter O'Rourke* **kept the shutter open for a full two minutes to provide a correct exposure. The buildings can be seen in full detail but have taken on a greenish tinge.**

DAYLIGHT FILM IN FLUORESCENT LIGHT

▲ There are several types of fluorescent light, all producing different colour casts on daylight film. This particular type gives an overall green cast.

▲ If you don't know the type of light you have to compromise. Use CC20 or 30 magenta, or FL-D filters.

▲ A small proportion of green light has been absorbed by a magenta colour compensating filter, and colour rendition has been slightly improved.

▲ You can use a CC10 magenta filter to correct a colour shift. Although both shots are good, the second version (right) is closer to reality.

Ultra-violet and skylight filters

All films are naturally very sensitive to the blue end of the colour spectrum. Film emulsions have to be treated during manufacture to make them respond properly to yellow, orange and red light. Even after such treatment, however, films can be disproportionately affected by the blue content of visible light as well as by ultra-violet (UV) rays which are invisible to the human eye. Under certain conditions daylight includes a surprisingly high proportion of these invisible rays which can have an adverse effect on your photographs.

With colour film, the print or slide may have an unacceptable blue appearance with a bluish haze over distant parts of the scene. The intensity of colours may also be reduced. With black and white prints the overall contrast may be low, distant detail hazy, and there may be slight loss of sharpness with a degree of over-exposure of the film which makes the print paler.

What causes haze?

Haze most often occurs when humidity is high, particularly in the summer. In a humid atmosphere specks of dust in the air pick up minute droplets of moisture. As sunlight passes through this suspended water vapour the shorter wavelengths of the spectrum (blue and ultra-violet) are scattered more than longer wavelengths (red). This results in a blue haze. The farther you are away the more droplets of water you are looking through and the stronger the haze appears. Haze is therefore most notice-

◀ **Haze reducing filters: top left UV, right Skylight 1A, bottom Skylight 1B.**

▼ **Although invisible to the naked eye, ultra-violet (to which films are sensitive) abounds over mountains, hiding distant detail in a blue haze.**

able on a distant landscape scene. In a photograph the flattening effect of haze and the blue appearance is even more pronounced than you remember when viewing the scene. This is because the film responds to the scattered invisible ultra-violet as well as to blue light.

Most UV from the sun is absorbed as the sun's rays pass through the earth's atmosphere. A certain proportion always gets through, however. The greatest UV content in the atmosphere is found at high altitudes, but UV is also abundant over and near water. It is strongest around noon with the sun in a clear blue sky.

Water, mist and snow all strongly reflect UV, and when these are included in a photograph a UV absorbing filter should be used to improve colour and clarity.

HAZE REDUCING FILTERS
▶ **Film is sensitive to all colours of the spectrum which make white light, and to invisible UV. Here a dip in the colour band signifies that the filter concerned absorbs light from that part of the spectrum—exaggerated for clarity. A UV filter absorbs most UV but has little effect on violet or blue light, and none on the rest of the spectrum. Skylight filters 1A and 1B also absorb UV, but they improve colour pictures by partly absorbing other colours in the spectrum. The 1A gives slightly warmer tones by absorbing some blue-green while the 1B absorbs more green and gives better skin tones.**

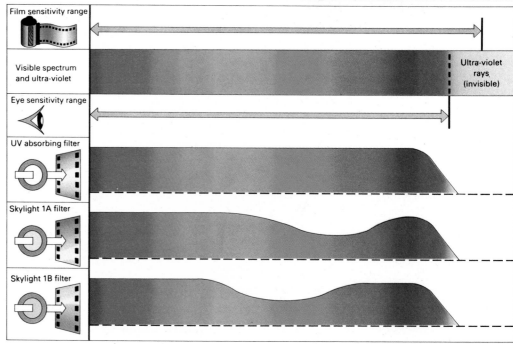

Film sensitivity range

Visible spectrum and ultra-violet

Ultra-violet rays (invisible)

Eye sensitivity range

UV absorbing filter

Skylight 1A filter

Skylight 1B filter

▼ A UV filter absorbs some of the ultra-violet rays which are scattered by water vapour in the atmosphere. The distant mountains are defined much more distinctly than in the view on the facing page. Although a UV filter reduces the effects of mild haze and improves picture clarity, it cannot remove the overall blue colour cast.

UV (or haze) filters

A UV (or haze) filter looks almost colourless, but can have a marked effect on photographs. The UV filter absorbs most of the UV rays which are invisible to the eye but to which all films are sensitive. The UV filter has no effect at all on colour balance or exposure. It is mainly intended for use with black and white films where you want to improve distant detail and contrast. The excess blueness caused by over-reaction to visible blue light is not noticeable on black and white films.

Many people leave a UV or haze filter over the camera lens all the time to protect the front surface from damage. Using a UV filter as an 'optical lens cap'

is perfectly acceptable, the filter being removed only if another filter type is to be used.

Many long telephoto and mirror lenses, which have a facility for small rear-mounted filters, have a UV filter fitted as standard. This can be removed and replaced by other filters as the need arises. Some lenses have special UV absorbing layers forming part of the lens coatings, which act as a UV filter.

Skylight filters

A skylight filter not only reduces haze caused by scattered UV, but improves the colour balance of colour photographs, by absorbing small amounts of blue and green light too.

So if you use colour and black and white film, choose a skylight filter rather than a UV filter. You can keep it on the camera for both types of film.

Skylight 1A: This filter may, at first glance, appear colourless, but if you place it on a sheet of white paper you will notice that it has a slight pink tinge. This prevents some of the visible blue light present in the atmosphere from reaching the film. The tones are therefore less blue (ie they become slightly 'warmer') in the slide or print. The filter also absorbs some UV radiation therefore reducing haze. The result is a more contrasty, colourful picture—in fact more or less as you viewed it by eye. The 1A filter is suitable for mild haze.

Skylight 1B: This filter is a slightly deeper pink than the 1A. As well as having slightly greater haze-penetrating powers than the 1A, the 1B also absorbs more visible green light and is therefore more effective in improving colours.

● Use a skylight filter with colour film, whether slide or print.

● Use the Skylight 1A for general landscape photography, on humid sunny days, near water, and for outdoor portraits.

● Use the Skylight 1B in mountainous regions, on dull days, and when the sky is blue and clear. The 1B will also reduce blueness when taking photographs in open shade.

● Pictures of snow appear less blue when photographed using a 1B filter.

● Within an hour or so of sunrise and sunset light is redder (or 'warmer') so a skylight filter is rarely needed.

● Leave a skylight filter over your lens whenever you can for extra protection.

Using other filters

Many filters absorb UV and reduce blueness in colour photographs apart from the UV and skylight filters dis-

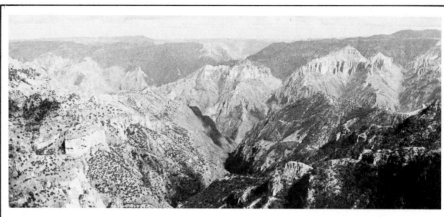

▲ **No filter: haze over these Mexican mountains has recorded on the film, giving a soft, flat print.**

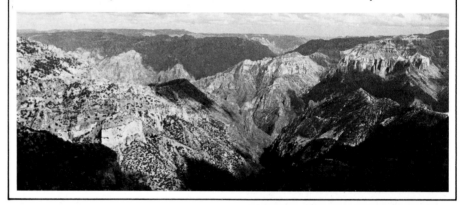

▼ **UV filter: penetration of haze and slight increase in contrast improves the scene.** *Anne Conway*

▲ **No filter: although the foreground is the focal point, the hazy hills in the background lack depth and are lost in pale insignificance.** *Anne Conway*

▲ **With Skylight 1A: slight penetration through haze gives more differentiation between the hill ranges and adds an extra dimension to the photograph.**

cussed. Any pink, yellow or salmon-coloured filter has the same effect. Light balancing filters 81A, 81B and 81C (pale salmon-colour), pale-straw colour and red and yellow colour compensating (CC) filters all reduce haze and 'warm-up' colour tones. Some photographers use them as a matter of course to improve skin tones. Depending on how dark the filter colour is, the exposure may have to be increased. Exposure guides are generally included when you buy a filter.

As different films have different responses to colour, the exact warm-up filter needed can only be found by experiment. For example Kodak Ektachrome slide film has a greater tendency towards blue results than Kodachrome

and some Agfa-Gevaert slide films. Filters which do not absorb ultra-violet include all blue filters, close-up lens attachments, and special effects prism attachments.

Electronic flash
Many flash units have either a high ultra-violet content or a high colour temperature. Some flash guns have a rated colour temperature of 6000K which is bluer than standard daylight (5500K) for which daylight films are balanced. This means that some flash pictures will have a slight blue bias. But if you want to warm the tones slightly, especially of skin, use a Skylight 1B filter over the camera lens; an 81A filter has greater effect.

▲ Top, no filter: light from flash guns can be cold and harsh, often producing unflattering portraits with washed-out skin tones. Bottom, with Skylight 1B: the slightly pink colour of the filter has cancelled the cold effects of flash for a better portrait.

▶ Exploiting haze: you don't always have to minimize haze. *Mike Yamashita* made the most of abundant UV near the water and mountains.

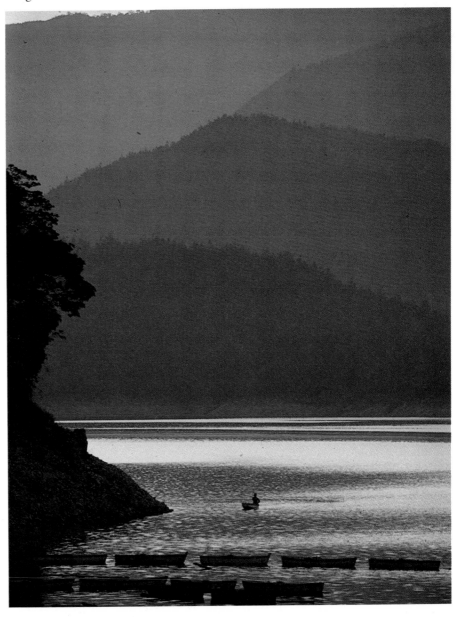

Polarizing filters

A polarizing filter fitted over your camera lens can produce dramatic changes and improvements in your photographs, including reduction of distracting reflections and increase in colour intensity.

Polarizing material can be bought in small or large sheets, unmounted. But most people prefer to buy mounted polarizing filters which they can conveniently screw on to the front of the lens. While the rigid mount remains fixed in position on the lens, the actual filter part can be rotated.

You can use the filter in several ways, the most important are described here.

Darkened skies

Because it is not in itself coloured, a polarizing filter is the only filter which you can use to darken skies in colour photography. On a clear day, blue sky in a zone from about 30° to either side of the sun contains partly polarized light. You can use a filter to darken this area and reproduce the sky as a deeper blue. Rotate the filter until you see maximum darkening through the lens.

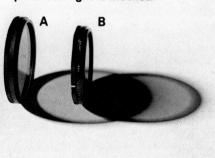

▼ Light through polarizer A becomes polarized. The grids in filters A and B are parallel so light is allowed through B.

▼ Filter B has been rotated so that its polarizer grid is at right angles to that of A. All polarized light is blocked.

Polarization of light from the sun lessens towards the horizon. You may find that a dark patch appears in the centre of the sky when using an ultra-wide angle lens. Clouds are not affected by polarization. This means that on a bright day with blue skies and white clouds you may be able to pick out brilliant white cloud formations against a vivid blue background.

▶ (Below right) the first picture of this pair is correctly exposed but has a pale, uninteresting sky, while the exposure made using a polarizing filter gives a rich, deep blue sky—exposure had to be increased.

▼ These deep, intense colours are the characteristic result of using a polarizing filter. *John Claridge*

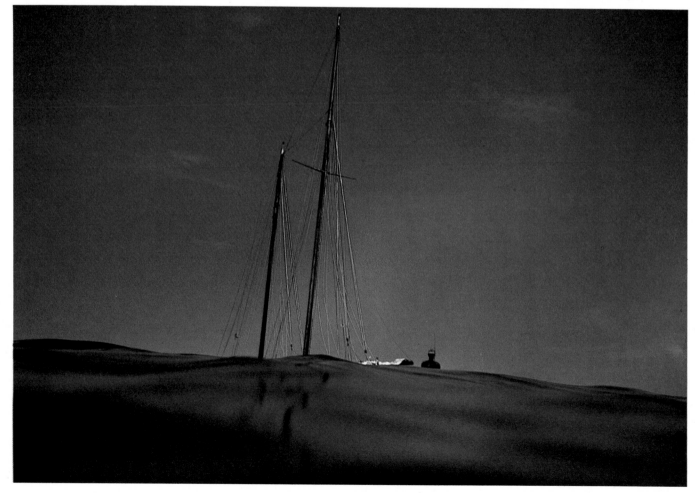

How polarizing filters work

Light travels in straight lines in the form of waves, which vibrate in all directions about the axis of the beam. A polarizing filter has a microscopic structure which is like a fine grid of parallel lines. The grid only allows through those light waves which are vibrating in the same direction as the lines on the grid. If a light beam of waves vibrating at random passes through a polarizing filter, waves vibrating at right angles to the polarizing grid are stopped. Waves vibrating parallel to the grid are allowed through. The beam which emerges is thus made up of light waves which are all vibrating in the same direction or plane. This is called 'plane polarized' light. Because a polarizing filter lets through only a proportion of the light exposure must be increased.

When light rays are reflected some are realigned to vibrate in one plane only—the rays become polarized. You can use a polarizing filter to prevent these polarized light rays from reaching the film and therefore remove, or at least minimize, reflections. This applies to reflections from water, paint, glass, wood and so on. Metallic surfaces reflect light waves without polarizing them, and it is therefore impossible to remove reflections from metal. Light from a blue sky reflects off particles in the atmosphere and is often polarized.

When you rotate a polarizing filter you are changing the orientation of the grid in relation to both polarized and unpolarized light in the scene you are photographing. Hence rotating the filter varies the effect.

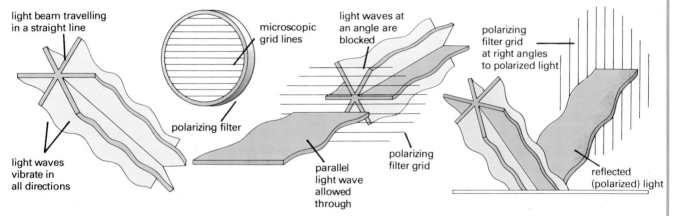

▲ **Although light travels in straight lines each wave vibrates on the axis of the beam (shown very simplified).**

▲ **A polarizing filter passes only waves vibrating parallel to its grid; other light is blocked.**

▲ **Polarized light (eg reflections) can be blocked by turning the grid at 90° to the polarized light waves.**

Controlling reflections

A polarizing filter can reduce unwanted reflections from many shiny surfaces. When the sun is at an angle to the surface of your subject, light rays may be reflected off it in a realigned (or polarized) form. The degree of polarization depends on the angle at which light hits the surface. Reflections from surfaces are most fully polarized when the reflection angle is about 50° to the surface. Reflections seen from this angle can be supressed effectively.

Polarization of light happens with water, polished wood, paint, glass, wet roads, shiny leaves, and any other non-metallic surface which produces reflections.

Polarizers cannot remove reflections from mirrors, which have a metallic reflective coating (although they can reduce some reflection from the front glass surface). Similarly, do not expect to remove reflections from chrome-plated car fenders.

You can, however, use a polarizing filter to reduce reflections from a shop window (a sharp reflection), enabling you to photograph a display within. Use one when photographing polished wood (which produces diffused reflections) to show the wood grain. Rotate the filter rim until you minimize reflections as seen through the viewfinder. You cannot necessarily remove all the reflections.

▼ REFLECTIONS: **light is reflecting off the water and into the lens, masking all detail just below the water surface.**

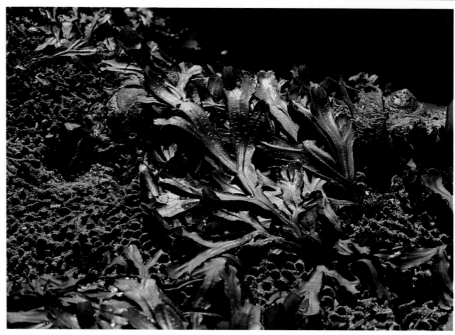

Colour and texture

Reflections from glossy surfaces often hide bright, deeply saturated colour and detailed structures underneath them. The effects of trying a polarizing filter on ordinary scenes can be surprising because everything from hair and skin to grass, rocks and leaves can be 'veiled' by a sheen of polarized light.

It is not necessary to use a polarizing filter for every picture you take, however. At times, especially in black and white where you cannot record colours, a surface sheen may make the picture work.

▲ **COLOUR AND TEXTURE:** *Heather Angel* **photographed this seaweed without using a polarizing filter; the reflection masks colour and texture.**

▶ **Using a polarizing filter reduces reflections, dramatically improving colours and allowing the texture of the seaweed to show through.**

▼ **Although using a polarizing filter cannot remove all the surface reflections you can now see the submerged boat seat more clearly.**

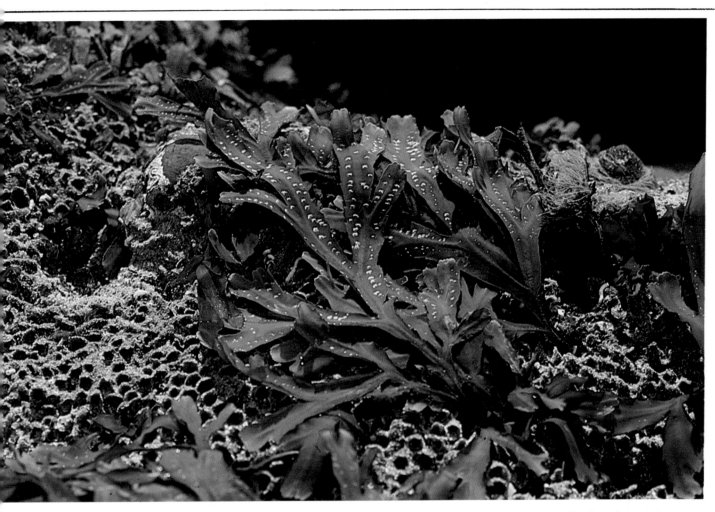

▼ PAINT AND METAL: light reflects apparently equally from paint and metal to produce an all-over sheen.

▼ A polarizing filter can reduce reflections from paint and other reflective surfaces, but has no effect on metal.

Stress patterns

If you have ever worn polarizing sunglasses and looked at a car windscreen you will be familiar with the multicoloured stress patterns which reveal themselves. View your plastic filter container or a clear plastic ruler in this way and you will see brilliantly coloured stress patterns.

You can photograph these stress patterns, and the best effects are shown with colour film. Photograph a transparent colourless plastic object against the light using one polarizing filter behind the plastic and another over the lens. Whether you take pictures using close-up equipment or through a microscope superb abstract images are possible.

Exposures

With some types of TTL (through-the-lens) metering cameras polarizing filters may give incorrect exposure readings. A polarizing filter cuts out a great deal of light—which requires extra exposure on the film. The safest routine is to take your meter reading without the filter fitted and then increase the exposure according to the factor engraved on the filter mount. The filter factor is often x2 which requires an increase in exposure of one stop.

One simple piece of equipment can make a tremendous difference to your photographs. A polarizing filter is a simple item which should find its way into every photographer's camera bag.

▲ STRESS: this strange effect often occurs when taking pictures from an aircraft window using a polarizing filter. The multicolour bands are stress patterns. *Dave Saunders*

▼ REFLECTIONS IN GLASS: Left, a shop window display can be hidden by reflections. Right: although it may be impossible to remove them completely, a polarizing filter can minimize them.

▼ WOOD GRAIN AND TEXTURE: Left: light from a nearby window is reflected into the lens and obliterates detail. Right: a polarizing filter is added and rotated until at right angles to the polarized light. It reduces reflections, so wood grain, colour and texture appear.

▲ HAZE: at high altitudes and in some hazy conditions there may be a considerable amount of scattered and polarized light. Try using a polarizing filter to reduce the haze in such conditions. Even at low altitudes a polarizer can be effective. *John Claridge.*

Choosing a wide angle lens

▼ Wide angle lenses from various manufacturers differ in design. Despite variations in size and shape wide angle lenses do have common features.

1 28mm extra wide angle lens
2 24mm extra wide angle lens
3 17mm ultra wide angle lens
4 18mm ultra wide angle lens
5 28mm extra wide angle lens

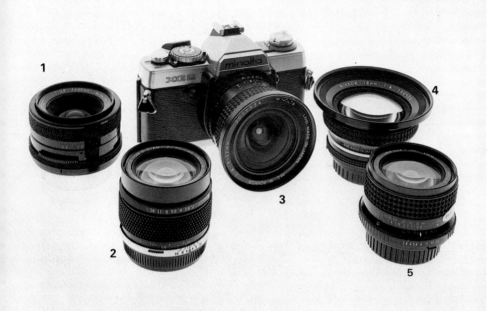

▲ A wide angle lens allows the photographer to change his view point and composition without moving much—a couple of paces changes the angle of a subject as much as 90°.

Look at this page from about 15cm away. Keep your eyes fixed on the dot below:

Don't move your eyes to look. Can you see your hands? Can you read anything apart from the words near the dot when your eyes are fixed on it? The answers should be yes and no, in that order.

Even with your eyes fixed on the dot and the page held as close as 15cm away, you still have some vision beyond the edge of the page—a full 180°. But only the central few degrees are really sharp enough for reading or seeing clearly.

The human eye has a wide field of view, and a wide angle lens does exactly the same thing. But in a photograph you expect to see sharp detail all over, not just in the centre like the human eye. The eye can move its sharp spot round but the camera can't; the lens must record detail corner-to-corner.

Wide angle lenses have a shorter focal length compared with the film size they use than standard lenses have. A 24mm lens is 'standard' for a 110 pocket camera (film size 13 x 17mm) but wide angle for a camera taking 35mm film (24 x 36mm). The shorter the focal length of the lens, the smaller the image it produces of an object at a given distance—you can get more surrounding image on as well.

But it's not quite that simple. An ordinary short-focus lens would produce that smaller image, but it would be surrounded by a dim area of unsharp picture—no good if you want the true wide angle recording of detail edge-to-edge. So lens designers have evolved special wide angle lenses which focus rays from the extreme edges of a wide field of view instead of losing them or bringing them to an imperfect focus. They have a series of glass elements which gradually bring the rays round the very sharp angles needed to focus them, using deeply rounded curvatures to gather the light. This usually means they can reproduce detail sharply between angles of 60° and 115°.

Retrofocus lenses

Wide angles with short focal lengths need to be very near the film—a 25mm lens would ideally have its optical centre about 26mm from the film, with some glass in front and some behind. But most 35mm SLRs have bodies about 43mm deep (lens mount to film)

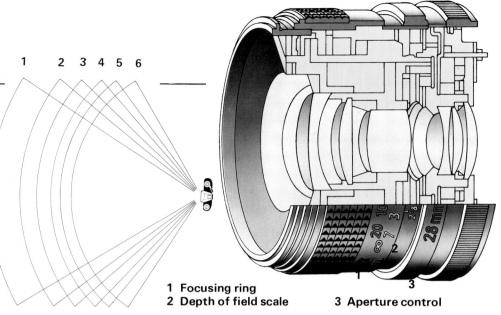

Focal lengths of wide angle lenses for 35mm SLRs
1 35mm wide angle 63°
2 28mm extra wide 75°
3 24mm extra wide 84°
4 20mm ultra wide 94°
5 17mm ultra wide 102°
6 15mm extreme wide 115°
These focal lengths and angles of view are approximate and differ from one manufacturer to another—a 15mm extreme wide angle lens can have an angle of view as wide as 180°.

1 Focusing ring
2 Depth of field scale
3 Aperture control

▲ View as seen through a standard 50mm lens on a 35mm SLR.

▲ A 35mm wide angle lens has a wider angle of view and gives greater coverage.

▲ A 24mm extra wide angle lens appears to push the scene even further back.

▲ A 17mm ultra wide lens creates perspective problems.

and mirrors which need about 30–35mm of clearance to swing up. To make the use of wide angles (35mm focal length or under) possible on SLR cameras, a retrofocus design is used. Most of the wide angle light-gathering is done by a set of glass elements at the front of the lens which contract the size of the scene in front—rather like binoculars used backwards. A set of rear lens elements resembling an ordinary camera lens 'sees' this reduced wide angle view and projects it on to the film.

Like all camera optics, these designs are complex and the dividing line between the front group and the rear group is often blurred or non-existent. But in some types you can look through the front group and see a diminished world, and use the rear separately to take photographs.

Choosing a lens

With wide angle lenses covering between 63° and 115°, there is some distortion on the wider angles. For a 35mm SLR, a 35mm focal length covering 63° may not be wide enough if your standard lens is 50mm; 28mm covering 75° would be a better choice. A 24mm covering 84° is going to extremes and, unless you particularly need this coverage with its risk of image distortion, the 28mm is the most sensible all-round choice.

Picture making

Wide angles increase your view of the overall scene but alter the effect of perspective in the picture. If there's a statue in front of a building it will appear to loom up out of all proportion as you move closer, while the background remains much the same.

These lenses give you more of the horizon, more of the sky—things you can't get by stepping back from a subject. But don't forget that you can move closer to nearby subjects—people, buildings, cars—provided you keep the subject away from the edges of the lens to avoid distortion. Wide angles give you a panoramic background automatically, but moving closer lets you keep the main subject as large as with a standard lens.

You can also move round subjects to vary that panoramic background. If you are 15 metres from a subject using a 200mm telephoto lens, you have to circle round a long way to move 90°. But with a wide angle you would be only 2 metres away, and a short walk would move you 90° round. Fewer obstacles get in the way at 2 metres, too.

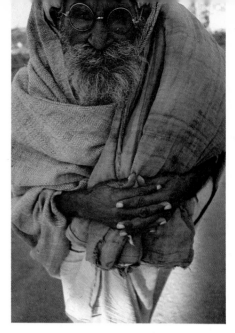

From 3 metres away, dropping on your knees for a low viewpoint has little effect on how you see a standing figure —you look up at about 15°. But from 1 metre, dropping to your knee gives an angle of 45°. The closer you are, the greater the effect of small changes in camera position. Even the range of positions available by moving from side to side, kneeling, or taking a single step have great effect with wide angle lenses.

Using a wide angle lens, you can choose a close detail for the foreground with a given background and then, by moving round a bit, choose another detail without changing the background. So moving 2 metres might change the scene from one with flowers in the foreground to one with scrap iron, but without altering the background significantly. The great depth of field of a wide angle lens means you can keep both foreground and background perfectly sharp. Holes in walls, interesting windows, breaks through undergrowth, and so on, will frame your picture sharply if carefully used.

If small changes in viewpoint make big differences, extreme viewpoints—from on top of a wall, or from the ground— have an unbelievable effect. A 24mm lens on a 35mm SLR gives vertiginous views from only 2 metres up, and a 17mm used from ground level makes a crowd look like giants. The familiar converging vertical lines can be exaggerated by ultra-close viewpoints to make ordinary two-storey buildings seem like tower blocks.

If you use converging lines for effect, design the picture so that the lines run out of it in a balanced way—not symmetrically, but with a clear central vertical axis and without leaning over to one side. To make your verticals perfectly straight, hold the camera precisely vertical. You may need to climb on a chair to compose an interior correctly, or photograph a building from a first floor window across the street. If you have a tripod, swing the camera round to line the screen edges up with verticals to check for exact parallelism. Even better, buy a camera-top spirit level to fit your accessory shoe.

For the candid photographer, wide angles let you pre-focus the lens at about 2 metres, set the aperture to f8 and get good results anywhere between 1·5 metres and 2·5 metres. This is ideal for rapid-reaction snaps in the street, in crowds, or when people think you are too close to photograph them.

To see the world in wide angle terms, always relate foreground and background and move your viewpoint round to juxtapose them. The wide angle world is dependent on small key details as well as global views. The good wide angle photographer looks closely at these details despite the apparent affinity of wide angles for overall scenes.

Practical aspects

Exposure metering: because wide angle lenses take in a larger view there is more chance of including a big shadow patch or an expanse of bright sky, giving extreme contrasts or unbalanced areas of bright and dark.

Generally, SLR through-the-lens (TTL) metering systems give accurate . or slight under-exposure with wide angles. Over-exposure is rarely a problem unless you photograph a small light detail on a black background. For accurate wide angle metering, move in close to take the reading or aim the camera/meter down to eliminate excess sky. In contrasty scenes pitch the exposure for the parts which are most

▲ A wide angle lens can be used very effectively for a portrait. From close to the subject an almost overall view is obtained. *Tomas Sennett*

▶ These extremely dramatic figures were photographed from close to the ground. Because of the way a wide angle lens distorts perspective the figures and the palm appear to be converging. *Jon Gardey*

▼ By photographing the subject from nearby with a wide angle lens the torso appears less dominating, drawing attention to the hands and the action of the subject. *David Kilpatrick*

important to you.

Focusing screens: despite popular belief, most modern SLRs are very easy to focus even with wide angles like 20 or 18mm; their microprisms work perfectly. Screens which show a high proportion of the real picture area (over 92%) and allow you to see really sharp detail in the corners, are best.

Depth of field: short focus lenses, including wide angles, have great depth of field. You can often take a photograph of two subjects a long way apart and get both of them sharp if the lens is stopped down. Sometimes this great depth is hard to avoid and pictures become muddled, so do not hesitate to use a setting like 1/1000 at f5·6 if you need to cut out the 'total focus' effect of 1/125 at f16.

Depth of focus: inside the camera, depth of focus at the film plane is very limited with wide angles. There is no room for error so if the film is not positioned correctly you won't get a sharp image.

Convergence and divergence: the close viewpoints and wide view of short lenses can make perspective seem exaggerated. Aim up and buildings seem to stream up to a vanishing-point, or lean; aim down and things grow up like mushrooms; aim along and a road or rail track sweeps away dramatically. Use this deliberately by using strong angles, or avoid it carefully by keeping your camera dead parallel to buildings for perfect verticals. Never accept slightly converging verticals and always balance your picture.

A feature available on some 35mm SLR wide angle lenses is the facility to shift the lens to correct converging lines.

Filter threads: because wide angles depend so much on mount design to avoid cut-off corners, and may use large front glass areas for best performance, filter sizes can be inconsistent even within a range. However, you should be able to find 35mm, 28mm and 24mm lenses to match your standard lens filter kit. You may be able to get 20mm lenses too, but for sub-20mm wide angles larger filters are universal.

Watch out for

● Filters, lens hoods and other accessories on wide angles— they may cut off the corners of the image. Your SLR screen may only show 88% of the true picture area, so mistakes like

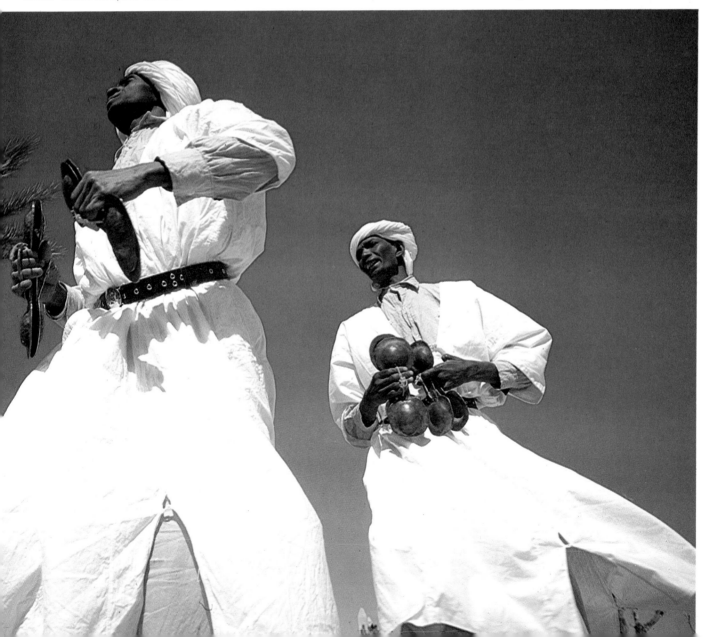

this won't be spotted until you see the photograph. Buy the slimmest filters possible and the correct lens hood—if in doubt, take some test shots with the lens set at infinity and the smallest aperture.

● Wide angles may have large areas of glass—avoid scratching them. Use a lens hood if possible, and a UV filter.

● Avoid shooting into the sun with the sun just out of the frame. If you have a depth of field preview, always check that the wide angle is not throwing up flare when working against the light.

● Cheap wide angles may turn straight lines into slight curves, especially near the edges; they may not be very sharp in the corners, and may not take good close-ups.

◀ The curve of this round-fronted building is further emphasized by a wide angle lens which, because of the vertical format, here creates converging verticals in the perspective.

▶ The great depth of field of a wide angle lens makes it possible to compose a picture with a strong foreground while retaining background detail as well. *Tony Evans*

▼ The figure merging with the tree is distinctly set off by the flat background. *Michael Boys*

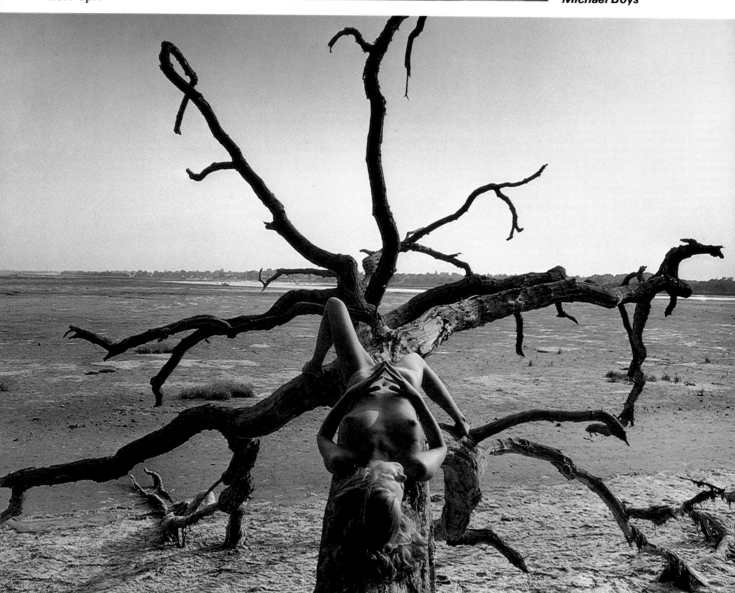

Medium telephoto lenses

When you look at a scene, it doesn't matter very much to your eye whether an important part occupies a tenth of your view or over half of it—in fact, to see, something comfortably it needs to be at a suitable distance, not too close. A face is just as 'important' at 3 metres as it is at 1 metre, and nobody looking at a house or tree from the other side of the road would feel compelled to cross over to get a better view.

That is because your eyes can pick out very small areas of detail and 'read' them, ignoring the rest of the scene. Only when something is very small and very distant do we find aids like binoculars or a telescope useful, because the subject has gone beyond the limit of our visual resolution— that is, beyond the point where we can pick out fine detail.

There is also a limit to the amount of fine detail which can be contained in the small area of a photograph. If you take a colour slide of a distant subject there is no point in projecting the slide on to a screen and then looking at a small area standing close to the screen. It makes sense for the subject to fill most of the picture, so that the finest possible detail can be seen without distracting surroundings. It is not simply a question of moving in on the subject—this isn't always possible. A long focus or telephoto lens is the answer, because it has the effect of bringing the subject closer.

A long focus lens has a longer focal length than a standard lens for any given film size. It produces a bigger image of the subject (a higher magnification). A special optical design has been devised to produce compact lenses which can reduce the size by up to half. This design is called 'telephoto'. Today the term is so widely used to describe any lens giving a magnifying effect that 'telephoto' tends to refer to any long focus lens, and not just those using a compact design.

With all telephoto lenses, a doubling of the focal length produces twice the image size on the film. Lenses up to 200mm for 35mm SLRs (equivalent to about 350mm on a large format SLR) are included in the medium range; the longer telephotos, as well as zoom lenses, are dealt with in separate articles.

To choose a medium telephoto lens you have to decide on its main function. If your standard lens is 50mm and you do a lot of portraits, then 85–105mm could be the answer; 135mm gives you freedom in candid shots and 200mm gets into the action in sports photography. For general photography a good choice is a telephoto of around 100–105mm.

Picture making

Standing in one place with a 135mm lens (on a 35mm SLR), you could photograph more than 20 entirely separate views without overlapping. That even allows a few degrees to spare between each shot if you just keep moving round through 360°. If you add to that your ability to aim the camera up or down as well, then there could well be over 60 completely

**MEDIUM LENGTH TELEPHOTO
LENSES FOR 35mm SLRs**
1 100mm
2 135mm
3 100mm macro
4 200mm
5,6 telephoto converters
7, 8 lens mounts to fit lenses
from independent manufacturers
on to various cameras.

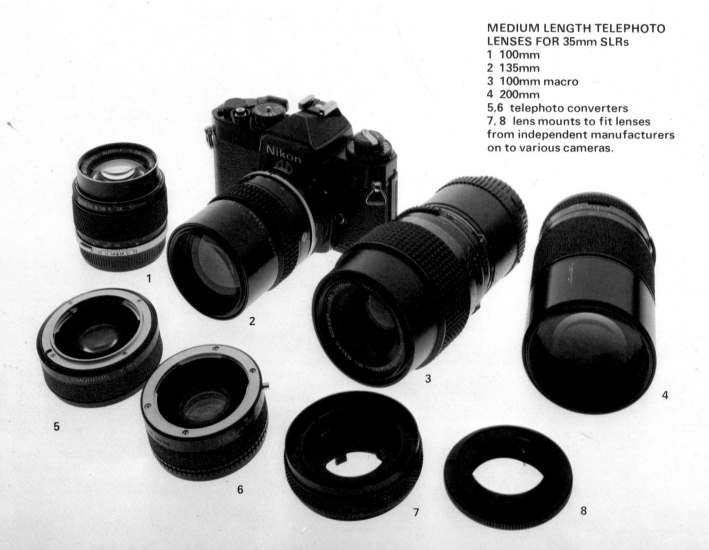

200mm MEDIUM TELEPHOTO LENS FOR 35mm SLR

1 focusing ring
2 distance scale
3 depth of field scale
4 aperture setting
5 bayonet fitting

Centre: the angles of view shown for various focal lengths are approximate as they can vary slightly in lenses from different manufacturers. The longer the focal length of the lens, the smaller the angle of view is. Maximum apertures are slower and depth of field also decreases. Angles are measured on the film frame diagonal.

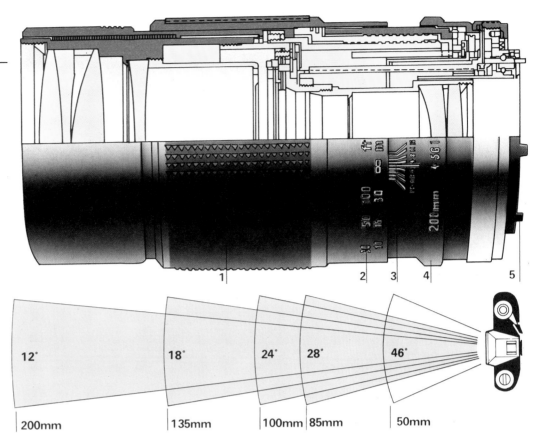

▲ **85mm lens** with this focal length on a 35mm SLR there is no obvious compression of planes.

▲ **100mm lens** moves the subject closer and the effect remains fairly normal.

▲ **135mm lens** —the background is slightly out of focus and obviously a 'tele' vision.

▲ **200mm lens** throws the background out of focus and the compression of perspective is strong.

Minimum focusing distances for medium telephoto lenses

Sometimes it is useful to have some idea of what lens to use in a given situation. In the cases below, portrait and full length are vertical compositions and 'car' gives a rough idea of how well an average car fits a horizontal frame side-on.

Lens	Portrait	Full length	Car
85mm	2m	4·5m	9m
135mm	3m	7·5m	15m
200mm	4·5m	10m	21m

These are examples of the distances you would need to have in order to manoeuvre and get a good shot. So, as you can see, there is little point in trying for a comfortably composed portrait with a 200mm lens in a room measuring less than about 6 metres, unless you want both you and the subject to be crammed against the walls.

Eventually you will get to know how much your own telephoto lens includes, and you can begin to see the world in telephoto terms—it is no longer necessary to actually fit the lens before you know if the subject is suitable. A very good idea is to walk around for an afternoon with the telephoto lens on your camera. It will familiarize you with the lens and show you how to be more selective.

different views from one standpoint. And if you use a 200mm lens, the number obviously increases. This is where selectivity comes in.

The key to successful telephoto photography is the ability to select those small areas in the scene round you which make good photographs—details, faces, 'landscapes within landscapes', groups of objects or people. But once you have spotted a subject for your telephoto lens you may have to move a long way to one side, or move closer in, to get the right angle and the best frame-filling composition. Because of this, telephoto shots are often the kind which you just see and shoot—the small incident, the interesting detail—as opposed to the kind which you visualize and then manoeuvre round to compose.

Shutter speeds for hand holding: where wide angle lenses allow you to use slow speeds with little more than a firm stance, telephotos of 85mm and over on 35mm cameras, and the equivalent on large formats, begin to show up any camera shake as unsharpness.

● The rule of thumb is the same for all lenses—use a shutter speed with a 'number' not less than the focal length of the lens for hand-holding. Use 1/125 with an 85mm or 100mm, 1/250 with a 135mm or 200mm. With all telephotos, especially when following action, try to use the highest speed your exposure will allow. Remember that the added weight and balance shift of a telephoto lens increase the possibility of camera shake, so use fast shutter speeds—1/250, 1/500 or even 1/1000—whenever you can.

Holding the camera steady: to avoid shake when it is not possible to use these fast shutter speeds, use a tripod, a monopod or some other support to keep the camera steady. For mobile action shots, you can buy a shoulder-stock with a trigger shutter release and for short telephoto lenses a simple pistol grip screwed into the base improves steadiness. If you cannot use extra support of this kind, make sure that you always grip the telephoto focusing mount when shooting so that one hand supports the lens and the other the camera.

Perspective problems: telephoto lenses are highly selective, separating subjects from their background or surroundings; and drawing them closer. Perspective is flat—there are no dramatic sweeping vistas to be seen through the telephoto lens—so that the emphasis is on isolating detail. Distances are not clearly recognizable, and with longer lenses—135mm or 200mm—the distance between planes in the final picture can be very hard to assess, each one appearing like a layer of scenery dropped down behind the main subject. There is still some perspective left, of course, especially with shorter telephotos. But the general feeling given is of solidness, flatness and lack of depth. The telephoto view is something we never see naturally unless we use binoculars—there is always a foreground edge in the field of our normal

vision to give us depth. Telephoto images often cut this out.

Selective focusing: as well as being selective in picking out details, the telephoto is very selective in its focusing. The limited depth of field results in differential focus, where the subject is picked out as a crisp image between an out-of-focus foreground and background. By using telephoto lenses at fairly wide apertures such as f4 or f5·6, you can be even more selective in focusing. Distracting backgrounds can be diffused and attractive backgrounds, such as foliage behind a portrait outdoors, can be softened.

If your camera has a depth-of-field preview button it can be used very effectively with a telephoto lens. It allows you to preview the stopped-down image on the focusing screen. You can then adjust the aperture to get the exact effect you want.

Obstruction: sometimes using a telephoto lens means that things get in the way; things you can't move because they are between you and the subject—

◀ The telephoto lens was used here to compose the picture. A standard lens would not have allowed such tight composition without moving up to the trees. *Michael Busselle*

▼ A telephoto lens made this composition possible without disturbing the seals. *Ernst Haas*

▲ Any attempt to approach the subject would have disturbed the tranquillity of this scene. *Michael Busselle*

◀ A medium telephoto lens can be used without a tripod providing there is sufficient light to allow a shutter speed with a number larger than the focal length of the lens being used.

▼ By focusing on the crossbar in advance, the photographer was able to concentrate on releasing the shutter at the exact moment the athlete would pass over it.

fences, branches or twigs, wire netting and so on. But if you use the telephoto lens at a wide aperture such as f4 the differential focus may make them seem to disappear altogether. Cage netting in zoos can be eliminated by putting the telephoto lens right up to the wire and working at f4 or f5·6 with a 135mm: but always check by using the depth-of-field preview before shooting.

Portrait problems: the limited depth of field causes problems when you move in close for a portrait. It is very tempting to focus on the hair or eyebrows, as they are good 'targets'. Always focus on the pupils of the eyes or the eyelashes —nothing looks worse than a well-focused nose and blurred eyes. Try to stop down your lens just enough to bring nose, mouth and eyes into sharp focus at the same time.

Panning: because telephotos have a limited depth of field, it may be necessary to focus while following a moving object. This involves panning to keep the subject in the frame and at the same time turning the focus ring enough to keep it sharp. Practice is the only way to perfect this technique. A far easier method is to preset your focus on a mark or spot which you know the subject will pass (a point on a race track, for example). You follow the subject in the normal way, ignoring the fact that it may be out of focus when you first see it through the viewfinder. As it passes the preset point you take the picture —though a good photographer presses the shutter an instant before to allow for the normal delay in our physical reactions.

The key to success is to keep the subject correctly framed and move smoothly through—follow it and keep following it even while you press the shutter. Do not stop moving the camera. If you stop when you press the shutter you will lose the subject. Slow speeds may be used with success if your speed is accurately matched to the subject—the background will blur, giving an effect of speed.

Technical aspects

Mounts: interchangeable mount telephotos are commonly available, and it is generally hard to tell the difference in quality between telephoto lenses of independent make and camera makers' lenses.

Contrast and colour rendering: telephotos may be low in contrast. Choose a multi-coated lens when possible and keep to one make only for consistent colour rendering.

▲ A medium telephoto lens allows the photographer to work without moving in too close to the subject. The subject tends to be less self-conscious. *John Kelly*

◄ Children often react to the camera without the shyness or awareness that adults have when being photographed. *Roland Michaud*

► By following the subject with the camera a sense of movement and speed is retained. *Suzanne Hill*

Lens hoods: many lens hoods sold with telephotos are too short. A lens hood about 75mm long can be used on medium telephotos of most types, and helps to protect the lens from dirt and knocks as well as from stray sunlight. Telephoto lenses may produce overall light flare without a lens hood if used into the light.

Filters: because telephoto lenses look at more distant subjects, any haze or mist will have a greater effect on the results. Always use haze cutting filters, such as UV and skylight filters. Never over-expose on misty days. Fog and mist cannot be penetrated but light haze can. Watch out for rising heat haze—no filter can stop this from producing poor sharpness in telephoto shots.

Filter threads: if a filter for your standard lens does not fit your telephoto lens it is usually possible to adapt the filter by using stepping rings. If using gelatin filters, of course, there is no problem as you can use a universal mount.

Exposure metering: a telephoto lens picks out a small area of the overall scene, and as a result only that area must be used to base the exposure on. If you are using a hand-held meter, a reading taken close in to the subject is desirable. If you are not able to go in close, which is one main reason for using a telephoto to begin with, a spot meter or narrow angle meter is useful. Most hand-held CdS meters have acceptance angles of about $20°$ and are therefore fairly suitable. With TTL metering cameras, the lens itself makes the close-up reading, and there is no major problem.

Focusing screens: telephoto lenses up to 200mm all work perfectly well with modern SLR focusing screens at full aperture—most microprisms and split-image range finders will function if the lens aperture is wider than f4·5, and few telephoto lenses up to 200mm are slower than this. To avoid 'bull's-eye' compositions a plain ground-glass screen with no central aids is useful as telephotos are very easy to focus on ground-glass, and a plain screen helps uncluttered composition.

Depth of field: telephoto lenses have a limited depth of field at wider apertures (f8 or wider) but can be stopped down to f16 with significant gains in sharpness. Never be deceived by what you see through the viewfinder at full aperture, which will eliminate distracting backgrounds by blurring them totally—always check with a stop-down preview, if possible. They may snap into focus at f11. Use differential focusing creatively to lose them, but avoid using too much—out-of-focus noses on portraits will result if you work wide open at f2·8 on a 135mm.

Lens weight and camera mounts: medium telephoto lenses can generally be used on all cameras without too much strain on mounts. If the lens you buy is equipped with a tripod bush (as are some 200mm f2·8s, and similar fast, medium telephotos), this is a clear statement by the makers that they think you should try to support the lens rather than the camera. With heavy lenses like this (135mm f2, 180mm f2·8, 200mm f2·8) avoid letting the camera hang from its neckstrap—if the lens mount does not suffer, the neckstrap attaching lugs may wear out, or the strap may break.

The versatile zoom lens

You are standing in the middle of a crowd, photographing a football match. With your 100mm telephoto lens the players look far too small when the action moves to the far goal mouth, but if you fit your 200mm telephoto lens you get cut-off heads and feet when players move near you.

You are standing on the edge of a harbour wall, photographing a lighthouse. You want it to fill the frame precisely, with no wasted space. Neither your 135mm nor your 200mm allows this—you need 163mm. If you could move in closer or move back, your problems would be solved—but you can't . . .

You are climbing a mountain, and don't want to be weighed down with equipment. Nor do you want to be changing lenses, as this occupies your hands, which are better used for climbing. But you want a wide angle lens for close-ups of your fellow climbers and a medium telephoto for views of the scenery.

These three problems have the same answer—the zoom lens. Zoom lenses have been called '100 focal lengths in one lens'—instead of producing a fixed image, they can 'zoom' in to magnify the image, or zoom back to get more in the frame. Zoom lenses were first introduced on cine cameras but are now almost universal on stills cameras, especially on 35mm SLRs.

Making a zoom lens is a fairly complex operation, though the principle is simple. If you change the separation between two elements (or groups) in a photographic lens, you change the focal length of the combination. But you also change other things like the distance of the film from the lens, and the f stop.

Modern zoom lenses use anything from nine to 18 glass elements, moving apart or closer together in tracks worked out by computer to change focal lengths without altering accurate focus settings or the f stop. In addition, all the usual aberrations and distortions which even normal standard lenses can have, must be eliminated as far as possible.

Cheap zooms tend to be optically compensated—that is, by careful optical design a relatively simple movement of one group in the lens does everything, zooming perfectly and holding sharp focus. But to achieve this, the lens may be bulky, have a limited aperture or poor performance.

The more expensive zoom lenses are usually mechanically compensated, with tracks allowing two or three groups to move in different directions as the lens is zoomed.

200–500mm

TAMRON

24–50mm

70–150mm

70–210mm

70–150mm

35–140mm

35–105mm

Zooms can cover an enormous range of focal lengths, like the Soligor 35–140mm and 70–150mm lenses, or a narrower range like the Rokkor 24–50mm. The long Tamron lens shown covers from 200–500mm. Many lenses have macro or close focusing settings like the Vivitar Series 1 70–210mm (it uses a push/pull zoom action) and the 35–105mm lens.

Most zooms are similar in size to the long focal length on their scale—for example, an 80–210mm zoom resembles a 200mm lens, not an 80mm. Wide angle and mid-range zooms may be even larger, though in the case of some pure wide angle zooms the reverse happens—a 24–50mm zoom is more like a 24mm than a standard 50mm. They are usually one f stop smaller than a normal prime lens of the longest or shortest focal length (80–200mm—f4·5, as opposed to 200mm—f3·5; 24–50mm—f4, as opposed to 24mm—f2·8). Regardless of size, most zooms are heavy because of the amount of glass and metal used.

Choosing a lens

To choose the kind of zoom you need, bear in mind your kind of photography.
• The family photographer needs a mid-range 35–80mm, ideal for everything from groups to portraits and children.
• The keen travel photographer might prefer a 24–50mm wide angle zoom.
• The sports enthusiast could benefit from an 80–210mm.
• The portrait photographer is better off with a 70–150mm.
But remember that the real enthusiast will pick a prime lens for his or her best pictures, because they tend to be better optically—so the wide angle man might buy a superb 24mm, and cover with an 80–200mm zoom for all those telephoto lengths he might occasionally need.
• Look for a zoom which balances well in the hand, and which has zoom and focus controls which, whatever the type, are easily distinguished.
• Focus should hold when zooming so that there is no need to re-set it after changing focal length.
• Long zoom lenses, such as 100–300mm, should have a tripod bush for mounting the lens, not the camera.

Advantages

The big advantages of the zoom—fewer lenses to carry, no lens changing, infinitely variable focal lengths—allow the photographer to work quickly and accurately, with less leg work involved in framing the subject properly, and more freedom to select the right viewpoint or moment of subject action.

Disadvantages

The disadvantages of zoom lenses are that they tend to be heavy; they are never as light as a single focal length 'prime' lens, and are often slower in lens speed (smaller maximum aperture)

▶ Cutaway view of telephoto zoom lens. Zoom lenses are made up of groups of lens elements which move to change the focal length and focus. The optics are complex and the number of groups and elements vary from one manufacturer to another. The front elements (below right) twist to focus the lens, the centre section slides or twists to alter the focal length. The rear element is fixed.

Focusing Correcting

Zoom

▼ The sequence below was taken with a 35–100mm zoom lens from the same point. The first shot, at 35mm (a wide angle covering 62˚) takes in the whole scene; 50mm (covering about 47˚) is equivalent to a standard lens on a 35mm SLR; 80mm (angle of view about 29˚) moves in closer to the climbers; 100mm (angle of view about 24˚) has the effect of a medium length telephoto lens.

| 35mm | 50mm | 85mm | 100mm |

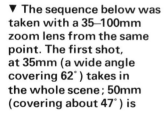

and of lower optical performance.
But if they seem expensive, you only
need to add up the prices of two or
three single lenses to find that price, at
least, is not a disadvantage.

Problems with zooms

Zooms and 'varifocals'—which are
zooms which need refocusing after you
change the focal length—are prone to a
few major faults.
Distortion: straight lines may appear as
gentle curves. noticeable with architec-
tural subjects or copying.
Poor coverage: zooms are more likely
to have fall-off in sharpness and
brightness in the picture corners.
Flare: the multi-element construction
of zooms can lead to flare.
Low contrast: the construction can also
produce low contrast generally, even
in good light.
Curvature of field: zooms may have a
curved field, with the centre focusing
in a different plane from the edges,
especially at close distances.

Picture making

Zoom lenses allow good composition
because the photographer does not
have to fit subjects into a fixed magni-
fication. They can also make a photo-
grapher lazy—he can frame-up with
the zoom rather than find a good angle.
To get the best shots you need to look
for good angles and then use your
zoom. Zoom lenses allow you to
photograph from a fixed position
when you cannot move freely, and also
to find the positions which might not
be usable with any fixed focal length
lens you own.
They also save time spent changing
lenses, so that you can catch many
shots which you would have missed
otherwise. The only exception is if you
work with two cameras—for black and
white and colour—one zoom between
two cameras causes as many hold-ups
as two lenses and one camera.
Just as you can pre-set the focus on
your normal lens to catch quick shots
you can also pre-set the focus control
and zoom control on a zoom lens—
but not necessarily to the average
setting. A 70–210mm zoom is best left
at 70mm, because it is much easier to
view a wide field and then zoom in
than it is to hunt for the subject at
200mm and pull back to frame it. But
a 24–50mm zoom could be better left
at 50mm.
With a zoom, you can change your
viewpoint and angle quickly without
losing the precise framing of the

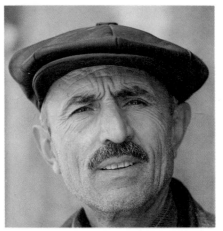

▲ Zoom lenses are ideal for candid
shots allowing the photographer to
compose a shot quickly.

◄ A 70–150mm zoom lens is useful for
portraits. It allows the photographer
to work at reasonable distances
from the subject.
Roland Michaud

▼ For sports photography, where
players move from far to near,
an 80–210mm zoom lens is useful.
At its longest focal length it is
still possible to capture the
action, even from a distance.
Don Morley

subject. So moving away 2 metres does not mean getting a smaller image unless you want that to happen. Zooms give you freedom to control perspective as a result of this—notably wide angle zooms. In general photography, where you may not want to devote thought to exact viewpoints, they save time by giving a good frame-filling composition without the necessity of worrying about viewpoint.

Zooms are at their best for photographing people and children. A photographer moving round, closing in and backing off, can be off-putting to adults and children alike. With a zoom you can be less demanding and obtrusive—no more 'back a little more, please', or moving forwards for a closer viewpoint.

Zooms are excellent for sports work, where you can frame-up different

points on a track or field from one position without changing lenses. You can use the pre-set focusing techniques for action work, or follow by panning, just as you can with a telephoto, and with push/pull zoom rings, you can often zoom back to catch a moving subject too. Always remember, when following a moving subject with a zoom, that both focus and zoom rings may need changing—the best answer is a zoom with one collar for both.

Zoom lenses are not ideal for landscapes and architecture, mainly because of their characteristics. Though landscape work can be done on zooms, most will give some degree of curvature to straight lines near the edges of the picture—and that includes the horizon. If no horizon is included, then zooms are perfectly acceptable, but in some cases, such as

▼ A zoom is especially useful when your subject is at all nervous. The photographer stays in one place and can change focal length as quickly as if he was focusing.

▶ When covering sporting events the photographer's movement is likely to be limited. Here a zoom comes into its own; no awkward lens changes or weight. *Julian Calder*

calm seascapes with the horizon right against the frame edge, the effect is poor. Architectural shots on wide angle zooms suffer from the same problems, accentuated by the straight lines of architecture.

A familiar effect with a zoom is the long exposure during which the lens is zoomed, producing a rushing or streaked effect. Mount the camera on a tripod, keep the main subject dead centre in the photograph, and use a small f stop so that the exposure is more than 1/8. Press the shutter while operating the zoom control, either increasing or decreasing focal length of the lens. With longer exposures, such as 10 seconds, in low light, a better effect can be had by letting half the exposure be made at a fixed setting and then zooming for the second half.

When you use a zoom, your technique can vary according to the way in which the end result will be produced. If you take colour negatives for sending away to be developed and

printed, always make a point of composing the shot exactly, but allow a little margin on the length of the photograph as most prints are not as long and narrow as the 35mm shape. For slides, you can use the full area that you see on the screen, and zooms help you to do this perfectly.

If you print your own photographs from negatives, you can plan for odd shapes—square prints, or long thin prints—by imagining the result on the camera screen. But using a zoom still helps you get the sharpest and least grainy prints by making full use of the negative. And if you zoom carefully, composing accurately, you will not need to change enlargement during a session. So you can keep to standard exposure and filtration settings for all the shots on your roll of film.

Practical aspects

Exposure metering: there is no need for special methods when metering zoom lenses—they behave just like prime lenses of their focal length. But

you can use the zoom facility to take selective meter readings or cut out bright sky areas before setting the correct focal length.

Focusing screens: because zooms are sometimes of low aperture—the f5 100–300mm for example—focusing screen aids, such as split image wedges, may not work. For long telephoto zooms a plain ground-glass screen is the best solution. Otherwise, expect zooms to be a little harder to focus generally than other lenses. A bright screen is best.

Aperture changes: many zooms have a variable maximum aperture—that is, 35–100mm, f3·5 to f4·3, meaning that at 35mm the lens has a maximum aperture of f3·5, but at 100mm this drops to f4·3, a half stop change. Always check whether the rest of the scale—f5·6, f8, f11, f16, f22—is linked to this change or not. In some types of zoom, setting f8 at 100mm would actually give you f9·5 because there is no compensation. In others, it would give you f8 correctly. Open aperture

▲ A zoom lens made it possible to shoot this picture cutting out the photographer's shadow. *John Garret*

◀ Expressing movement with a zoom; alter focal length during a long exposure to give double blur. *Gerry Cranham*

▶ Panning and altering the zoom setting gives another impression of speed. *John McGovren*

▼ A wide angle zoom at shortest focal length.

metering systems automatically compensate—but flashguns, for example, do not.

Changes in depth of field: remember that you should always pre-view your depth of field at working aperture and working focal length. It changes if you zoom, and checking it at 80mm does not help you judge the result at 135mm.

Changes in focus setting: although zooms are meant to hold accurate focus when you zoom, many do not. There is a slight variation, within acceptable limits. However, if you focus quickly at 70mm and then zoom, without checking, to shoot at 210mm, there may be enough error to give you a bad picture. So always either focus at the longest focal length, or at the setting you use to take the picture.

Lens hood, flare and filters: always use a hood if possible, and avoid shooting into the light without first checking the stopped-down effect, as flare patches may appear with many zooms. Check that hoods and filters do not cause cut-off at short focal lengths by taking a picture set at infinity and fully stopped down.

Filter threads: most zooms now have moderately normal filter fittings—tele-zooms may have threads as small as 49mm but are more usually around the 55–62mm mark. In camera makers' series of lenses, the zooms often have the standard thread. Mid-range zooms and wide angle zooms, however, are far more likely to have very large filter threads—62mm, 67mm or even 72mm. Filters in these sizes sometimes have very thick rims which can cut off corners, so check before buying.

Mounts: most zooms today come from independent makers, and nearly all of them are available in the popular camera fittings and with interchangeable mounts. Because zooms from independent makers are often just as good as camera makers' lenses (if available) and normally a fraction of the price, buying an intermount lens is a very good policy. Even if you change your other lenses when you change your camera, you can keep the zoom.

Long telephoto lenses

Although the human eye is capable of picking out very small subjects from a great distance, it can rarely see the detail on the subject clearly—we recognize things partly because we know what they are when we see them, rather than because we see them perfectly. Even a vague glimpse is enough to tell a bird-watcher what type of bird is flying far overhead, from movement and shape, although the visual image may be nothing more than a tiny silhouette on the eye's retina.

That is all very well for recognition, but for study and close observation we need magnifying systems, such as binoculars and telescopes, to see detail. In photography the same problem arises and the solution is much the same—you could certainly pick out a distant car with a 50mm lens on a 35mm SLR, but if you want to read the number plate or recognize the driver, much more detail is needed.

The answer for this sort of photography is the high power or extreme telephoto lens. These lenses involve optics which photographers call 'long toms' if built with glass lenses, and 'big cats' (catadioptric) if mirrors are used, as in the case of reflector telescopes.

The big problem with long lenses is bulk—a 1000mm lens should, in theory, be a full metre long and is hardly the sort of thing that can be held comfortably. Another problem is the maximum aperture. An f4 1000mm lens would have a front glass at least 250mm in diameter before the metal rim was fitted. Add length and weight to such big, heavy mounts and glass elements, and a third problem is created—no camera could hold the lens properly and the average tripod would not be strong enough.

There are two solutions which combine to make the 'long tom' a viable lens. The first of these is the telephoto construction which collapses the light path to make the lens smaller—perhaps half or less its focal length. Secondly, very long lenses have limited apertures, such as f6·3 or f11. Accepting this limitation gives a lens small enough to use normally. Even so, to keep their size within reasonable bounds, most long telephoto lenses use a tripod mount on the lens, not on the camera, so that the weight is balanced better.

Conventional long lenses

These long telephoto lenses are rarely more than 45cm long, and usually take filters which are less than 82mm in size (or special rear mount filters). Conventional telephoto lenses are available with various features.

Internal focusing lenses do away with the cumbersome focusing collars round the front of the lens and require no heavy mechanics. These lenses can be very sensitive to small changes, making them useful for rapid focusing.

Squeeze grip lenses have a pistol-type grip which alters the focus setting as you squeeze, so that an action photographer can follow action and focus in one movement, while keeping a hand free to release the shutter.

Fluorite element lenses use crystal lenses instead of glass to make very light, compact, highly corrected telephotos; for example, a 300mm f2·8 would not be unduly heavy. High-speed telephotos for sports work have apertures like this, or f4 for a 600mm, and normally use fluorite or non-glass elements in the lenses.

Mirror lenses

These lenses use optical mirrors to fold the light path by reflection, as well as glass elements to focus and correct the image. This produces more compact lenses than the conventional lenses. Typical mirror lenses are about 15cm long and very light, with a focal length of 500mm and a fixed aperture of f8; though lengths from 250mm f5·6 to 2000mm f16 are available. These lenses, known as 'big cats' (catadioptric), have a fixed aperture. Another design of mirror lenses, known as solid catadioptric, allows even more compact lenses, but they

▶ **Long telephoto lenses with the angle of view in brackets, from the left: 500mm (5˚), 1000mm (2·5˚), 400mm (6˚) and 800mm (3˚). The 500mm and 800mm lenses incorporate the catadioptric design.**

▲ A 50mm standard lens with an angle of about 46˚ gives an overall view of the church.

▲ A 300mm lens, used from the same spot, has a narrower angle of view and has the effect of being closer.

▲ A 1000mm lens, with an angle of view of about 2·5˚, isolates detail from a distance.

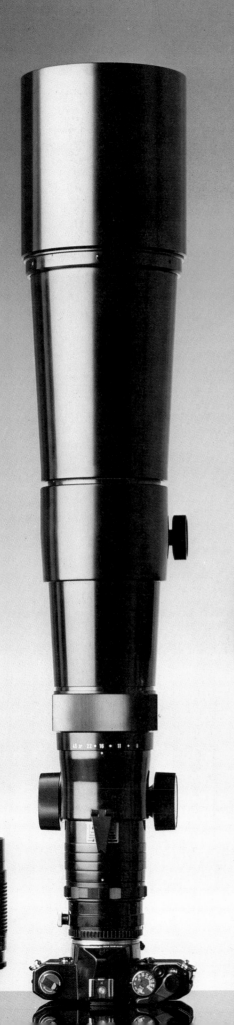

◀ A catadioptric, or mirror lens can be hand held with faster shutter speeds. These lenses, with fixed apertures, have a limited depth of field and careful focusing is essential.

▼ Catadioptric lenses use reflex mirrors to contract the overall length of the lens.

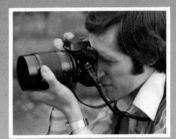

are heavier. Reflector telescopes are also available; these are similar to mirror lenses and can be used as such. Mirror lenses have O-shaped apertures and out-of-focus light points print as doughnut shapes. (See also page 56.)

Choosing a lens

Long telephoto lenses are useful for specific things. Generally, use 300–500mm for wild birds, motor cycling, car racing, sports, and air shows; 500–1000mm for water sports and wild life.

Bear in mind that you can use converters to increase the focal length of lenses—2x and 3x converters are available for SLR cameras—see overleaf—(though these are not recommended for catadioptric lenses unless specially matched). So, if you have a 135mm lens you can increase it to 270mm with a 2x converter—if you can do this, a 300mm lens is obviously of little use, so buying a 500mm lens would make more sense. This in turn can be used with a 2x converter to get 1000mm.

Picture making

Lenses over 300mm do not produce any wide variety of pictorial results, and most photographers would be hard put to tell the difference between a 400mm and a 1000mm shot unless there are tell-tale signs, such as the 'doughnuts' produced by mirror lenses. The common pictorial effect is of extreme spatial compression, stacking subjects up in a compressed perspective, often with people behind the main subject looking larger than they should.

The unfocused image with long telephotos is a hidden trap. Some insignificant little road sign adjacent to your subject and way behind becomes a big blur of red, and shapeless splashes of colour are sometimes unavoidable. But this is also an asset, turning all backgrounds, unpleasant or otherwise, into diffused patterns.

Mirror lenses, with their doughnut shape of apertures, produce similarly shaped out-of-focus patterns, especially from highlights such as reflections on water, and double-edged unfocused images from other details. This can be a creative effect or a fault depending on the use made of it. Hexagonal diaphragms, normally used for economy on long telephotos of conventional design, produce hexagonal unfocused image patterns when stopped well down, and again these can be obtrusive or creative depending on the use made

▲ Long telephoto lenses distort perspective by foreshortening distance. A 300mm lens was used to photograph this vineyard. *Patrick Eagar*

▼ Using a telephoto lens made it possible to lose completely the distracting background of this dahlia hybrid. *John Sims*

▶ The doughnut shaped circles of confusion are characteristic of a catadioptric lens. By prefocusing on a point on the track the photographer was able to get this shot at the exact moment the athlete was in focus—the runners in the rear appear out of focus due to the limited depth of field of the telephoto lens. *Gerry Cranham*

of them in the picture.

Mirror lenses are limited to one physical aperture and therefore to one depth of field, which is also less than the depth of field given by a normal lens. With a 400 ASA film in bright sunlight, 1/1000 at f8 may be one stop of over-exposure, and the answer is a 4x neutral density filter which reduces the amount of light reaching the film.

With all lenses over 300mm, regardless of maximum aperture, you should be able to 'lose' wire netting or other obtrusive foreground material completely by placing the lens hood up against the wire or whatever, and opening the aperture fully. Never shoot through ordinary window glass —it produces serious unsharpness with long telephoto lenses. Bold, simple, clear subjects make the best shots, and subject counts more than photographic quality or creative skills. Finally, do remember that long telephoto lenses enable you to invade privacy and you should resist the temptation to misuse them. Very long lenses have been mistaken for guns in the past, with unfortunate results— they look aggressive, and not everyone knows what a telephoto lens is. So don't invite trouble by looking for it through an 800mm lens.

Focusing distances

The following is a guide to give some idea of focusing distances for various subjects.

Portraits: 300mm lens, 5–8 metres, depending on required size of face.

Wild birds: 500mm lens, 5 metres or closer.

Motor cycle racing: 300mm lens usually good for close-ups from the side of the track.

Car racing: 300–500mm, only useful for distant parts of track, otherwise too long for versatility.

Sports events: 300–500mm generally good from usual spectator distances.

Wild life: 500–1000mm to give good close-ups at acceptably safe distances.

Zoos: 300mm more than adequate, 500mm normally too long except for small fauna and birds, outdoors.

Water sports: 500–1000mm usually best because of distances involved.

Air shows: 300–500mm for normal flying height, aerobatics and fly-pasts.

Astronomy: 1000mm lens produces good-sized image of full moon.

Sunsets: all lengths over 300mm produce good results, but 500–1000mm shots can be very dramatic with the sun in the picture.

Tele converters

Once you discover the capabilities and limitations of your camera system you will have an idea of what additional lenses you need. Most people choose to buy one or more telephoto lenses, but these items are expensive. By buying a tele converter you can at least double your lens range, economically. For example, if you already have a 50mm lens, fitting a 2x converter doubles its focal length to 100mm; again, a 135mm telephoto lens used with a 2x converter becomes 270mm. In both cases you have two lenses in one for perhaps half the cost of a telephoto lens.

A telephoto lens consists of a group of positive (converging) elements with a group of negative (diverging) elements behind it. Adding a separate negative lens group (a tele converter) behind an existing lens therefore increases the focal length. Tele converters are comparatively inexpensive, compact and versatile.

Until recently, converters (also called extenders or multipliers) were often of poor quality. Optical quality has in general improved, and now many camera manufacturers make their own to complement their lens range. Converters are available for almost all 35mm and 120 roll film SLR cameras, and they can be used with zooms, high resolution telephoto and mirror lenses and Leica rangefinder cameras.

What a converter does

A tele converter magnifies the central portion of a prime lens image. A prime lens is any normal lens, used without attachments. A 2x converter doubles the prime lens focal length, while a 3x converter trebles it (so that a 100mm prime lens becomes 300mm). This applies equally to zoom lenses—a 70–150mm lens fitted with a 2x converter has its range increased to 140–300mm, for example.

The converter fits between the prime lens and the camera body. The focusing scale on the lens always remains correct, and you can focus on infinity. Normally all the couplings for the camera are linked through the converter so that functions like aperture adjustment and depth of field preview remain fully connected.

A converter always reduces the speed of a lens because enlarging an image makes it dimmer. A 2x converter makes a prime lens two stops slower, 3x loses three stops, and a 1·4x converter one stop. With a 2x converter, for example, a marked f11 would effectively be f22. The change in exposure

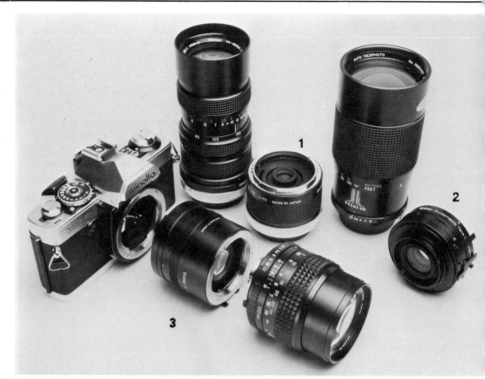

▲ A wide range of tele converters is available to fit most camera makes.
1 Vivitar's 2x Matched Multiplier is designed for their 70–150mm zoom lens.
2 A 2x converter doubles the focal length of a lens.
3 The larger 3x converter trebles focal length.

◄ Tele converters fit between camera and lens. The lens focusing scale remains correct, and all automatic functions are usually retained.

caused by this reduction in effective aperture is automatically calculated by a TTL meter. You can also find the true f number with a hand–held meter.

Types of converter

Universal converters fit a range of cameras and are available in different 'strengths' The cheapest type is the manual stop–down 42mm screw 2x converter with three optical elements. Converters designed to fit a whole range of lenses aim to keep aberrations to a minimum, and this often means that they will give superior performance with lenses outside their range. Zoom lens converters usually fall into the second category. Any zoom lens's performance varies through its focal

length range, and most converters can only give their best performance at one particular focal length.

To get round the problem of converters which amplify lens faults and perhaps even add new ones, some manufacturers make matched converters for specific lenses (Canon fluorite telephotos and Vivitar's 70–150mm zoom, for example). The matched converter may even bring in a little correction which the prime lens might lack for one reason or another—this is the most expensive type.

Matched converters for lens ranges or individual lenses should give better saturation and contrast, more even illumination and be freer from distortion than the cheaper universal types.

▲ This photograph was taken using a 70–150mm zoom set at its shortest focal length, 70mm. Notice the framing of the subject and the size of the building in the distance.

▲ Same viewpoint, same lens, but this time used with a 2x converter with the lens set on 150mm. This gives the equivalent of a 300mm lens.

Advantages

Besides being an inexpensive way of increasing your lens range, carrying one or two tele converters with you rather than a whole assortment of telephotos means that you have far less bulk and weight to accommodate.

Because the focusing scale remains unchanged, larger image sizes than normal at the minimum focusing distance are possible. A 2x converter on a 50mm lens can give one–third life size image (on 35mm film), while using a 3x converter can increase this to about half life size.

Disadvantages

Blowing up part of an image reduces sharpness, just as enlarging a small portion of a negative does. A converter produces a softer image than a prime lens under the same conditions.

The loss in light can also give an extremely dim viewfinder image, particularly with a zoom lens, making composing and focusing difficult. A converter may introduce its own edge aberrations and distortion giving fall–off in quality at the corners of the frame. This can only be minimized by using relatively small lens apertures which may demand use of slower shutter speeds, and perhaps a tripod.

Converters are least successful when photographing distant landscapes with aerial haze. A combination of only

▲ This ornate building was photographed with a 50mm lens which takes in a fairly wide angle of view and includes distracting foreground and surrounding detail.

▲ From the same viewpoint the photographer fitted a 200mm lens, which enabled close cropping of an interesting feature on the building without including extraneous detail.

▲ A 2x converter and 100mm lens are equivalent to 200mm. Loss of contrast and edge quality are hardly noticeable when compared to the results from the 200mm prime lens (left).

modest sharpness and low contrast produced by a converter and haze in the atmosphere can give flat pictures.

Using a converter

Converters are ideal for portraits when picture corner sharpness is not too important. The kind of softness obtained from a 50mm f1·4 with a 2x converter makes a fine 100mm f2·8 portrait lens.

In sports photography using converters can pull you closer to the action, and they are especially suitable if you uprate film for contrasty results, or use panning techniques when ultimate sharpness is of secondary importance.

Family groups and children rarely suffer from being photographed through a tele converter.

Remember that, as with all long focus lenses, pictures tend to have flattened perspective and shallow depth of field.

Close–ups are likely to be successful with converters because attention is often concentrated on the central area, there is no aerial haze, and close detail, not contrast, makes the picture.

Most converters need the prime lens to be stopped down to about f8 for the optimum results (which means a true

f16 with a 2x converter). Only specially matched converters work well at full aperture and allow high shutter speeds to be used.

Buying a converter

Buy the best quality you can afford and choose a matched converter if possible. Whatever your choice, don't expect the quality of a 100mm plus 2x to equal the performance of a good quality 200mm prime lens. Quality loss is particularly noticeable when working at wide apertures.

Buying a 2x converter gives you a 100mm portrait lens when used with a standard lens. This won't clash if you later buy a 135mm lens, and in fact gives a 270mm telephoto.

It does not make sense to buy a 2x converter and a 100mm telephoto—a 3x converter would be better because you then get 150mm from a 50mm standard, and 300mm from the 100mm telephoto.

A 2x converter extends the range of a 70–210mm zoom to a long 420mm. The range of focal lengths provided gives a wide choice with just two items of equipment. Again, don't be over–optimistic about the quality of the

▲ **Whatever converter you use, the lens focusing scale remains correct. A 3x converter fitted to a 50mm lens focused at 0.45m produced this impressive close leaf study.**

results, especially if the zoom leaves a little to be desired initially. Zooms in macro modes usually have too many aberrations to allow the use of a converter.

If you really intend to get the most focal lengths at minimum cost choose prime lenses with reasonable gaps between them—such as 135mm and 300mm—or a zoom.

Contrary to popular belief, converters work well on wide angles and macro lenses—they work on any lens which gives a sharp, bright image. But who needs a mediocre lens produced by converting 24mm f4 to 48mm f8 when your 50mm standard lens is far better?

Converters are an important and versatile part of today's camera outfit, and regardless of how many lenses you may buy, and what changes you make, they always double the number of choices you have. In fact the only thing you can never do with a tele converter is to use it on its own.

◀ Converting your 50mm lens to 100mm with a 2x converter gives a convenient portrait lens with a slightly soft edge quality.

▼ *Patrick Eagar* used two 2x converters on a 400mm lens (equivalent to 1600mm) to capture this distant island in a soft hazy atmosphere.

▲ This is the type of low contrast result typically produced by using a tele converter. The scene was photographed against the light and through aerial haze and is reproduced as a soft misty view, lacking depth. A 55mm lens and 2x converter were fitted to the camera.

Mirror lenses

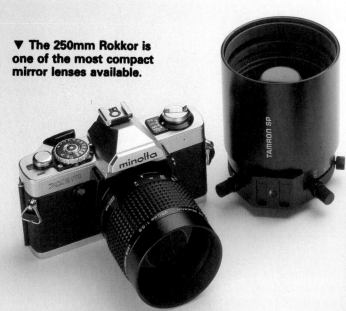

▼ **The 250mm Rokkor is one of the most compact mirror lenses available.**

◀ **Like the Tamron 500mm, most mirror lenses have a tripod bracket.**

▼ **The Sigma 600mm mirror lens can focus as close as 2 metres.**

▲ **Mirror lenses longer than 1000mm are unusual.**

Beyond 300mm, conventional telephoto lenses are bulky, heavy and can make the camera unbalanced. Mirror lenses are light, compact long telephotos which are convenient and portable. They are drum–shaped, with an opaque disc in the centre of the front element, and they work on the basic principle of internal mirrors reflecting the image back and forth inside the 'drum' to produce a long focal length in a relatively small physical space.

Advantages
The enormous advantage of mirror lenses is the difference between a metre–long telephoto lens weighing several kilos which has to be tripod–mounted, and a short lens which can be cupped in your hand, perhaps left on the camera on a neck strap, and which weighs little more than a conventional 200mm telephoto.

In some cases a mirror lens can give better quality than an equivalent focal length telephoto simply because it is easier to hold, focus and manoeuvre at speed.

Disadvantages
Besides being fairly expensive, mirror lenses generally have one or two drawbacks. They all have a fixed aperture, commonly limited to about f8; this produces a relatively dim image, which is difficult to focus in poor light. Illumination often falls off

▲ **Mirror lenses are easily recognized by their drum shape, and always have a blank disc in the centre of the lens front element. The inner surface of this disc is a mirror.**

◀ **Because mirror lenses are smaller and lighter than their telephoto focal length equivalents they can be much easier to hold and to use.**

◀ **The diagram compares the difference in length between a mirror lens and a telephoto lens of the same focal length (800mm). The shorter mirror lens is lighter and therefore more manageable.**

towards the edges of the frame. Overall contrast may be low, and flare and ghosting may result when the lens is aimed into the sun.

Temperature changes sometimes alter focal length and upset optical corrections by expansion of metal and mirrors. Slight knocks can put a lens out of alignment which would mean an expensive and specialized repair.

Choice of mirror lenses

Mirror lenses are available in focal lengths from 250mm to 2000mm. Avoid the very cheapest types—most give uneven coverage and excessive flare—and buy the best you can afford. The Minolta RF Rokkor 250mm is little larger than some 50mm lenses for a 35mm camera. Its compact size makes it an ideal choice for candid portraits.

The most popular type of mirror lens is the 500mm f8. The focal length is ideal for a wide range of subjects—sports and wildlife, for example—as well as being a good step up if you already own a 300mm telephoto. A 600mm is a good alternative, and both focal lengths can be compact designs.

An 800mm lens is a good choice for long–distance sports and timid wildlife, and makes a good team with a conventional 400mm lens.

1000mm mirror lenses are the upper limit of popular mirror lenses. The aperture is often only f11, and your camera must be capable of fast shutter speeds to avoid camera shake. They are generally used for picking out distant detail, such as an old building on the horizon. For the rare occasion when the average photographer needs such a long focal length a 500mm lens with a 2x tele converter gives you 1000mm.

Most mirror lenses are supplied with a well–made case, lens hood, fixed or detachable tripod bush, and a set of rear mounting filters—which might screw into the back of the lens, or slip into a special slot in front of the lens mount. The filters are usually skylight, neutral density, yellow, orange and red.

Using a mirror lens

Mirror lenses up to 800mm can be hand–held or used with a shoulder stock. To prevent camera shake use a fast shutter speed, such as 1/500 or faster. Even in bright sun the small fixed apertures may demand use of a fast film such as 400 ASA. On dull days you may have to up–rate fast film to keep the shutter speed sufficiently high.

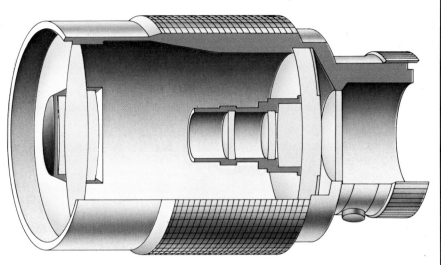

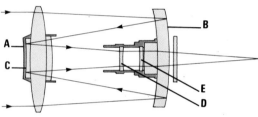

▲ The most common type of mirror lens — catadioptric. Mirrors and glass lens elements give optimum quality. A solid catadioptric lens uses identical optical principles but is of bonded glass elements with no air spaces in-between.

Types of mirror lens

Mirror lenses do not use only mirrors. Glass elements are often included to make minor corrections to the quality of the image. There are two types of mirror lens with photographic applications.

Catadioptric lenses incorporate a combination of mirrors and lenses, with small air spaces in between them. Alignment of the glass elements and mirrors is critical and the lenses should be handled with care.

Solid catadioptric lenses use solid glass elements with mirrored surfaces so that glass occupies the space taken up by air in a catadioptric lens. This prevents alignment problems because the mirror surfaces are bonded to the same cemented group of glass elements. However they are heavier than catadioptric lenses of equivalent focal length, and more expensive.

How mirror lenses work

Light from the subject enters the lens around the outside of the opaque disc (A) and reaches the large rear curved mirror (B). From here light is converged to hit the second smaller mirror (C). The image from the second mirror is focused on to the film, first passing through a series of correcting lenses (D and E) which improve the quality of the image.

An adjustable iris diaphragm cannot be included which means that the lens aperture is always fixed. Neutral density filters are the only means of controlling image brightness.

The overall diameter of a mirror lens barrel is wide to compensate for the unused central area blocked by the small mirror. The diameter has a bearing on depth of field—two 500mm f8 mirror lenses, for example, could give quite different depth of field results under the same conditions if their physical dimensions differ.

The aperture shape produced by the front opaque disc gives doughnut–shaped out–of–focus highlights and other image detail may appear double, or may have a characteristic 'plastic' quality.

Working with a fixed aperture means that the shutter speed is the only variable. An aperture priority automatic camera is the simplest type to use. A shutter priority automatic can only be used on the manual setting.

Accurate focusing may be difficult because the image is low in contrast. Pick out any sharp details on the subject, such as lettering, and use the plain area of your focusing screen. Generally speaking the final photograph will be sharper than the viewfinder image suggests. The best mirror lens pictures are of bold subjects, simple shapes and strong textures. It is better to photograph in clear, directional light, which provides some textural relief.

All the problems of extreme telephotography apply equally to mirror lenses. Just because the equivalent mirror lens is smaller and lighter, it does not lessen the quality-reducing effects of aerial haze, heat haze, wind, vibration and mirror jar. Don't try focusing through window glass, however clean it may be—it will impair image definition.

Creative work

Many photographers make creative use of the familiar out–of–focus 'doughnut' shapes produced by these lenses on flowers, light coming through leaves, sun on water, and many other subjects. Foreground detail can be thrown into extreme differential focus because of the limited depth of field provided by long focal lengths. Double images on linear subjects (such as branches and grass) are also attractive. More recent mirror lenses sometimes have very close focusing—two metres, for example—giving remarkable close–ups with differential focus. Although mirror lenses cannot be stopped down, some designs allow you to cut aperture stops (circles or discs) by hand, and tape them to the lens front. Experiment to see if this works—it does with most popular 500mm mirror lenses.

▼ **For maximum flattening of perspective** *John Sims* **used a mirror lens and chose his viewpoint carefully. He also waited for an oppressive, evenly overcast sky to provide a plain, featureless background.**

▲ **The long focal length of mirror lenses at close focusing distances gives limited depth of field. Here, extreme differential focus picks out one sharp poppy against a soft, unsharp background.**

▲ High above this river estuary a 500mm mirror lens has produced a rather unreal effect on the mud flats. Caught by the light, the boat dominates the scene. *John Sims*

▼ With an orange filter inserted in his 500mm mirror lens, *Chris Alan Wilton* created distinct doughnut shapes from the out of focus reflections on the surface of the water.

Special effects lenses

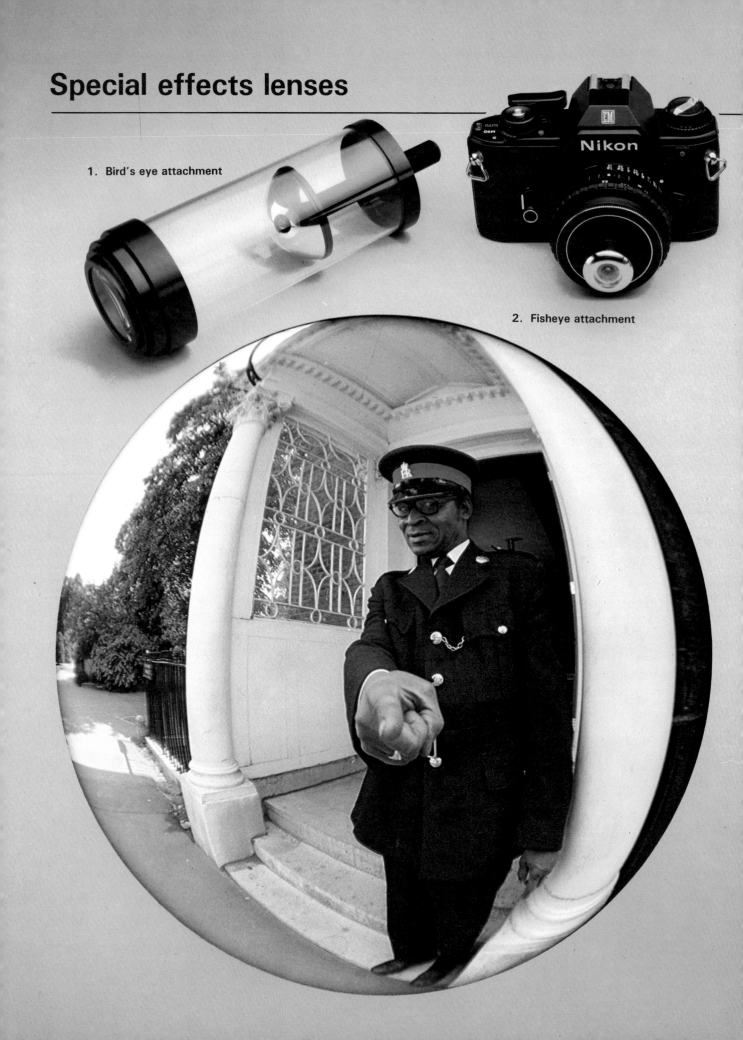

1. Bird's eye attachment

2. Fisheye attachment

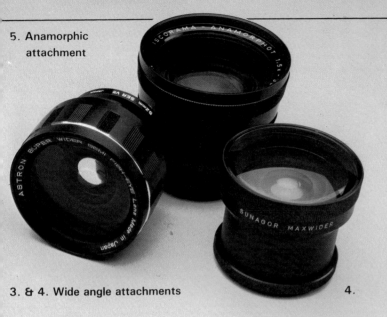

5. Anamorphic attachment

3. & 4. Wide angle attachments

4.

◀ 1. Bird's eye attachment which fits on the front of a lens, creating a round image with a black spot in the centre.
2. A fisheye attachment for a circle-image picture.
3. A wide angle attachment which increases the angle of view of a 50mm lens to 113° and of a 35mm lens to 150°. For best results the aperture setting should be f11 or f16.
4. A wide angle attachment that increases the angle of view of a standard 55mm lens to 104° and of a 35mm lens to 150°. The latter produces a circle-image picture.
5. An anamorphic attachment squeezes the image together. The resulting image is compressed and needs to be corrected to be viewed normally.

Attachments and lenses for special effects can distort the image—giving for example, a fisheye view—or they can improve the image by correcting perspective or increasing the depth of field. Prime lenses for special effects are expensive but they have specific functions. Lens attachments are less expensive and, although they do not give the same results as prime lenses, they too can create unusual images.

Wide angle effects

Although the easiest way of getting a wide angle view is with a wide angle lens (see earlier), there are attachments and lenses that can be used for extreme wide angle views and fisheye effects. For those wishing to specialize in wide angle shots there are special cameras for panoramic views.
Wide angle attachments: a standard 50mm lens or a 35mm wide angle lens can be converted to a wide angle or fisheye lens using a screw-in afocal adapter. Afocal wide angle adapters do not change the aperture of the lens or alter its infinity focusing setting, but they do have the effect of making the focusing scale inaccurate and giving a closer minimum focus. A 50mm lens may be converted to 30mm focal length, or a 35mm lens to 21mm. Some attachments produce more distortion than others, as a fisheye lens does.
Fisheye attachments: these attachments are similar to the wide angle attachments and screw into a standard 50mm lens. With a standard 50mm lens the attachment makes it equivalent to a focal length of 8mm—the usual focal length given for a circle image fisheye. These attachments are modestly priced but the resulting lens is usually limited to an aperture of about f8 or f11. Used on a 100mm telephoto lens, the attachment gives a 16mm full-frame fisheye, but the aperture is normally limited to f22.
Anamorphic attachments: intended mainly for cine cameras, attachments such as the Isco Widerama 'squeeze' the picture to fit 50% extra image into the length of the 35mm frame. The slide or negative which results is naturally compressed in one direction, so it must be printed or projected by using the attachment in reverse, which restores it to normal dimensions. The result produces a picture with dimensions of 2·25 to 1—or over twice as long as it is high—referred to as widescreen.
Bird's eye attachments: similar in effect to a fisheye lens, the Beroflex and other bird's eye-view attachments comprise a clear perspex tube fitted to the front of the standard 50mm lens. Inside the tube there is a spherical mirror facing the lens. The camera sees a 180° circular fisheye-type image, but with all the detail of the camera and the photographer in the picture too. The photographer can be excluded from the picture by supporting the camera on a tripod and using the delayed action setting, or with a long cable release.

◀ A wide angle attachment was used with a 28mm wide angle lens to shoot this circle-image picture. The effect is similar to an 8mm fisheye lens. (The attachment used on a standard 50mm lens would produce a full-frame wide angle image.) *Lisa Le Guay*

▶ An anamorphic attachment compresses the image in one direction and must be corrected to be viewed normally (far right).

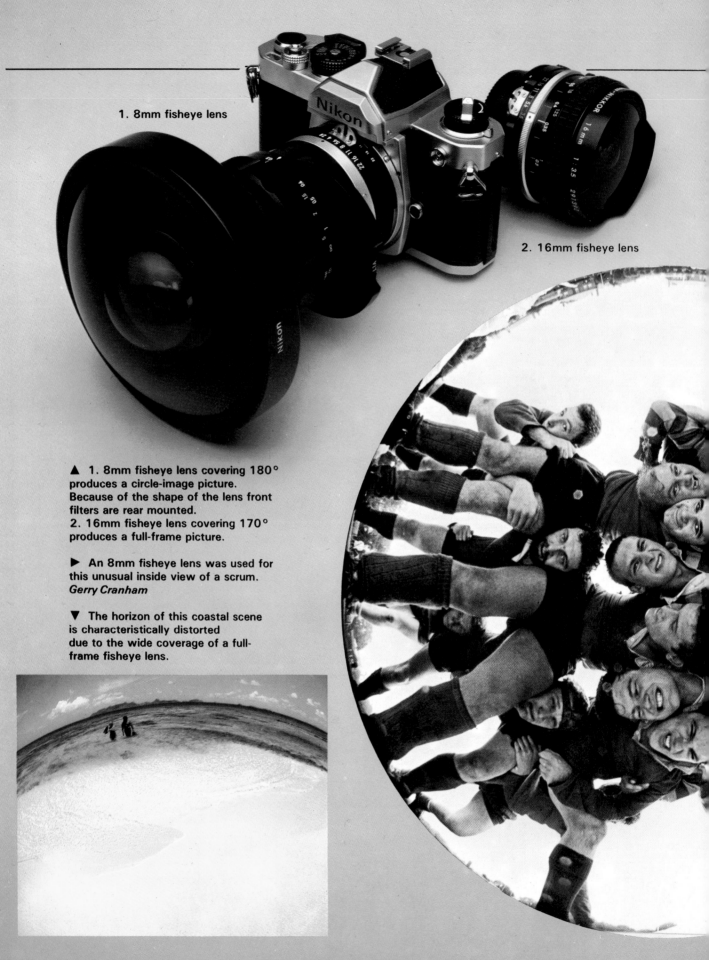

1. 8mm fisheye lens

2. 16mm fisheye lens

▲ 1. 8mm fisheye lens covering 180°
produces a circle-image picture.
Because of the shape of the lens front
filters are rear mounted.
2. 16mm fisheye lens covering 170°
produces a full-frame picture.

► An 8mm fisheye lens was used for
this unusual inside view of a scrum.
Gerry Cranham

▼ The horizon of this coastal scene
is characteristically distorted
due to the wide coverage of a full-
frame fisheye lens.

Fisheye lenses

Fisheye lenses (not attachments) produce full-frame or circle-image pictures depending on the focal length of the lens. For example a 16mm lens produces a full-frame picture while an 8mm lens produces a circle-image on 35mm film (both lenses have an angle view of 180°).

A full-frame fisheye lens: produces a characteristically curved image, where the straight lines normally seen are replaced by gradually curving ones,

and cover 180° diagonally on the film. If you are not careful you can include your feet or hands in the picture. These lenses are normally between 14mm and 17mm in focal length and around f2·8 to f3·5 in maximum aperture. They are about the same size as wide angle lenses of this focal length but are often cheaper as they are less complicated to make. Depth of field is enormous.

Circle-image fisheyes: by using the full image-circle of the fisheye lens, with its curved lines, it is possible to include

180° or even 220° all round, in a lens capable of photographing, for example, the entire sky in one shot for meteorological uses. A normal circle-image fisheye is of 8mm focal length and may be between f2·8 and f8 in maximum aperture. Other fisheyes with special optical characteristics are available between 6mm and 12mm, but they can be very expensive (notably those covering more than 180°, which actually sees part of the scenes lightly 'behind' themselves).

▲ A 28mm wide angle lens covers 74° and gives a panoramic view of a field—without horizon distortion.

▼ A 16mm full-frame fisheye lens covers 180° diagonally—more than twice as much as a 28mm lens.

Soft focus lenses

Special prime lenses are made to give a soft focus effect. Lenses today are corrected to produce sharp results, but sharpness is not always a good thing in portraits, where skin blemishes can show up badly. To overcome this and give a more atmospheric effect, soft focus lenses have a control which adjusts the glass elements so that they are wrongly spaced, producing uncorrected results with a characteristic glow or halo of diffusion round a sharp central image. The results do not look blurred (which is not the same) but hazy and romantic. Examples of current soft focus lenses include 85mm models from Fujica and Minolta and a 70 – 150mm zoom with soft focus from Tamron. Soft focus attachments, such as filters and mistys, imitate the effect of proper soft focus lenses by using treated glass or supplementary optics, but do not give as subtle a result. Soft focus generally is strongest at wide apertures, and soft focus optics can be quite sharp if stopped down to f16. These special attachments and lenses come in a wide price range. They all affect the resulting image and it is up to the individual to decide which are worth the expense. Let the subjects you enjoy photographing dictate your need for these specialized items.

Variable Field Curvature lens

Despite the computer design of modern SLR lenses, it is still hard to make a lens which always focuses its image on to a theoretically flat plane like the film. Expensive lenses having 'floating' elements which move to vary the field of sharp focus. By putting a control in to move the floating element manually, regardless of focused distance, Minolta have made a 24mm Variable Field Curvature (VFC) lens where the subject plane can be bowed or dished as well as perfectly flat, allowing subjects at the edges to be either nearer or further than those at the centre but still focused sharply even at f2·8.

Perspective control lenses

If you aim your 35mm camera directly at a building, without tilting it, you keep the vertical lines parallel. If you tilt the camera the lines lean in the resulting picture. If you cannot get back far enough even with a wide angle lens, then you have to accept converging verticals unless you have a wider coverage than a normal wide angle lens. By using a 'shift' lens you can move the lens upwards, bringing top parts of the picture which would normally be outside the film frame into it. Precise controls enable you to move the lens exactly the right amount to bring in as much or as little of the image as needed. Of course, these movements not only bring in picture detail from outside the edge of the picture, but also lose it at the other side. Perspective control lenses are 35mm or 28mm, manually operated, and have two directions of movement, or one plus the ability to rotate the entire lens.

Tilt control lenses

Some perspective control lenses also have an extra facility which allows the lens to be tilted or swung on its axis, pivoted so that it is no longer parallel with the film. When a lens is parallel to the film, it focuses on a plane which is also parallel to the film. If you tilt the lens the plane of focus is moved to an

▶ The background of this shot is out of focus as the depth of field was only deep enough to focus the vase and the flowers. The same scene photographed with a Variable Field Curvature lens has a sharp background (far right).

▼ 1. The Variable Field Curvature lens, made by Minolta, has a floating element which makes it possible to vary the field of sharp focus. It is particularly useful for close range subjects as the focusing range can be adjusted. .
2. The 35mm Shift CA Rokkor lens has a shift mechanism which corrects converging verticals.
3. The Canon 35mm tilt and shift lens is similar to a shift lens in that it corrects converging verticals, but it can also be tilted or swung on its axis so that the lens is no longer parallel to the film. This makes it possible to adjust the depth of field as well.

1. Variable Field Curvature lens

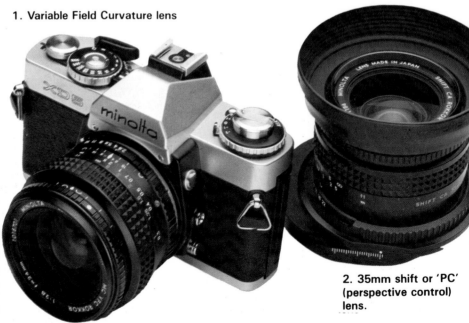

2. 35mm shift or 'PC' (perspective control) lens.

angled position by about double the amount of tilt on the lens, and in the same direction. So, if you tilt the lens 5° downwards, the plane of focus leans backwards by 10°. At 45°, a lens on a camera held vertically would focus perfectly on the ground. In fact, the mount of the lens and other considerations limit the amount of tilt you can use, and the extra coverage built into perspective control lenses is needed for effective tilt use.

3. 35mm tilt and shift lens

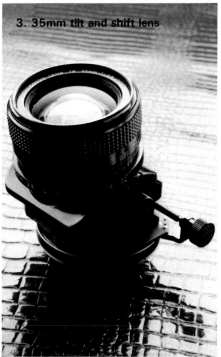

▲ A 35mm shift lens was used to photograph this village scene. The same scene (left), shot without the use of a shift lens, has converging verticals. The wider the angle of view, the more the lens distorts the image. This distortion of perspective can be very effective; but usually with architectural shots, especially when photographing tall buildings, a more realistic view is seen if the converging verticals are corrected. *Mike Newton*

Autowinders

An autowinder is a motorized unit designed to advance film automatically after each frame is exposed, and is a relatively recent phenomenon. To have motor-driven film transport built into the camera would need a major redesign, but because of the increasing use of electronics to control the various basic components it is a simple matter to provide contacts on the camera to connect to an external motor. The obvious place is the camera's base plate which provides direct access to the shutter and film transport mechanisms.

Motor-drive units are more versatile than autowinder units. They have been available for quite some time for a few high-priced cameras which are specially designed to withstand constant rapid shooting and film advance. By simplifying these and taking advantage of the more robust mechanisms in modern cameras, electro-mechanical winders are possible even with moderately priced cameras.

Although theoretically autowinders are simply for winding on film, most modern units are capable of continuous sequence, shooting up to two frames a second. The more sophisticated models rewind an exposed film back into its cassette.

Power

Autowinders consist of a low-voltage electric motor powered by small batteries—1·5 volt AA or AAA pen-light cells. The number of batteries required varies with the winder model and its features, but the average is about six. Manganese alkaline batteries are recommended because they last longer than ordinary batteries.

Construction

Batteries and motor are usually housed in a single unit, designed to follow the contours of the camera with which it is compatible. The winder top plate has electrical contacts for mating with

▶ Many different format cameras accept autowinders but you must buy a compatible unit to ensure correct operation. The Power Winder A fits all the cameras in the Canon A series and is shown here fitted to the Canon AV-1. It is a flush design autowinder, but some have built-in grips for easy manipulation, like the Chinon CE-4 (below right). The tiny Pentax 110 format SLR can be fitted with an equally small winder for single frame advance. The aperture priority Minolta XG2 accepts a flush design autowinder which fits some of the other Minolta X series 35mm SLR cameras.

▼ A special cradle eases battery insertion.

▼ An on/off and film rewind button are usually provided.

▶ Holding the assembly vertically is often easier if the winder has a grip.

▶ All autowinders give single frame film advance, but the great majority can also shoot frames in succession to provide a continuous exposure rate of up to two frames per second provided the release button is held down. This capability can be used to photograph moving subjects to form a sequence of frames, following the movement of the subject. The sequence can be used as a record and is also useful for teaching purposes. *Eric Crichton*

those on the camera base, together with a drive to engage the film take-up spool in the camera as well as a means for screwing the unit into the camera tripod socket.

The weight varies between models, but it is usually around 200–300 grammes without batteries. The extra weight is added to the base of the camera, thereby lowering the centre of gravity which makes a camera/winder combination stable and easy to manage. Although there is more weight to carry, the combined assembly is still portable.

Some winders have a built-in handle which makes the winder/camera assembly easier to hold and use—often these have an auxiliary shutter release. All winders have a tripod bush. Other features include an on/off switch and a warning light which glows when the motor is on or running. There is generally a separate control for selecting single frame advance or continuous running, and a release for film rewind so that the winder need not be removed from the camera to change film. Some models also have a battery test facility. Autowinders are not cheap, and are even more costly when purchased separately from the camera. However they are at least half the price of a motor-drive unit, and are available for many of the popular 35mm SLR cameras. One major disadvantage is that the autowinder must match the camera—they are not freely interchangeable between makes.

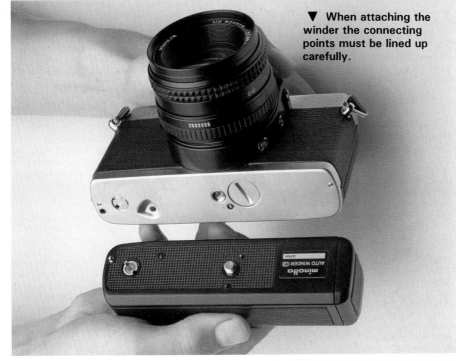

▼ When attaching the winder the connecting points must be lined up carefully.

Built-in winders

The Konica FS–1 is a 35mm SLR with a built-in autowinder; as soon as a film cassette is loaded and the camera back closed the film advances to the first frame.

After each photograph the film advances automatically and sequence photography is possible.

Agfa-Gevaert and Vivitar have several 110 pocket cameras with tiny built-in winders. The Agfa cameras accept top

SAF.ETY FILM 5031 KODAK SAF.ETY FILM 5031 KODAK SAF.E

▲ **Using an autowinder allows you to capture a whole series of 'fleeting moments' which you might well miss by winding on manually.** *John Garrett*

◀ ▼ **As the shutter priority automatic Konica FS-1 has an autowinder built in for automatic film loading and advance, no film wind-on lever is required. This looks rather strange at first. The Agfa 901 is one of the few 110 cameras with an integral film winder.**

flash allowing several flash pictures to be taken in quick succession.

Exposures

Using an autowinder is simple with an automatic camera, whether aperture or shutter priority. You simply set the aperture or shutter speed (according to the type of automatic camera in use) and the metering system automatically compensates for changing light levels. With a manual camera a little more care must be taken to ensure that you do not waste a whole roll of film if the sun unexpectedly disappears behind a cloud and you are operating the camera remotely. When using a manual camera you must make periodic checks to ensure that the aperture/shutter speed combination selected is appropriate.

Practical aspects

Using an autowinder relieves the photographer of the need to wind on manually after each exposure. Apart from the obvious convenience this gives a number of distinct advantages.
● It can take the photographer several seconds to release the shutter, engage the lever wind, advance the film and again sight and compose the subject—with the camera held vertically it could take twice as long. Using an autowinder enables another picture to be taken rapidly should the subject move, or perhaps blink.
● In extreme close-up work, when the camera is mounted on a microscope or telescope, or has a long telephoto lens fitted, the disturbance caused by exerting pressure on the shutter release may cause a disaster. Camera shake may result, the composition may be altered, or the region of sharp focus may be changed. Vibration caused by an

electro-mechanical winder is considerably less than that of the hand. Using an autowinder demands less time for vibration to die down before another picture can be taken.

● For self-portraits when the shutter is being fired via a lengthy cable or other type of release, the photographer would normally return to the camera to advance the film. Using an autowinder eliminates the need for this as well as the possibility of being out of position on return.

● In nature photography birds and animals are often more disturbed by human presence than by noise—they soon become accustomed to the gentle whir of the winder, and may even show curiosity, possibly with some comical results. Watching from a distance, the photographer can fire the shutter at the appropriate moment by using a cable or pneumatic release, or some form of remote control accessory, and continue to take pictures without disturbing the subject. If the winder is a little too noisy a sound-absorbing case or cover may help.

Sequence shooting

Pressing and holding down the shutter release allows most autowinders to operate continuously. The normal maximum shooting rate applies only in good light when fast shutter speeds can be used. Obviously if the shutter speed required for the aperture in use is longer than half a second, shooting at two frames a second would be impossible.

Sequence photography ensures the maximum number of pictures are taken in a short period of time (useful for rare opportunities of action shots which are difficult to repeat). Sequences of pictures can be built up when a single frame may not capture the vital moment. Typical examples are a horse jumping over a fence, a dog stretching lazily, or perhaps geese taking off and landing.

Accessories

All accessories which extend the capacity of an autowinder are expensive. Three examples are given, but in general they are only of interest to those who could make full use of the specific applications. Some autowinders can be fitted with an intervalometer or dosimeter, although this usually applies only to the more expensive models.

Intervalometer: this provides an automatic delay between each frame, typically variable between one frame per second to several hours or even days. The camera is set up and focused on the subject. When the first exposure has been made manually the photographer can leave the equipment to continue taking single frames at the pre-set intervals.

Dosimeter: this controls the maximum number of pictures in a single sequence. The precise number varies with the individual unit, but is often from four to 30 frames in regular steps. If it is used in conjunction with the intervalometer a sequence of pictures recording changes too slow to be perceived by the human eye at the time can be recorded (for example, flower growth). The photographer does not even need to be present after the initial pressure on the shutter release.

Data backs: although not specifically for use with an autowinder, data backs can help the photographer to document his sequence pictures. More sophisticated SLR cameras have a removable back which can be replaced by a data back which reflects a set of figures on to the film during exposure. There are normally three sets of figures which can be adjusted by three dials on the unit. The figures often correspond to day, month and year, but you can adapt the sequence to suit your own requirements. Some compact non-reflex 35mm cameras have a date imprinting facility built in—for example the Canon Datelux and Minolta Hi-Matic SD.

▼ Some photographers use an autowinder for some of their most successful animal pictures. Timid birds can be frightened by a nearby photographer. Pre-focus the camera, and hide, using an air release to trigger the shutter.

Better flash lighting

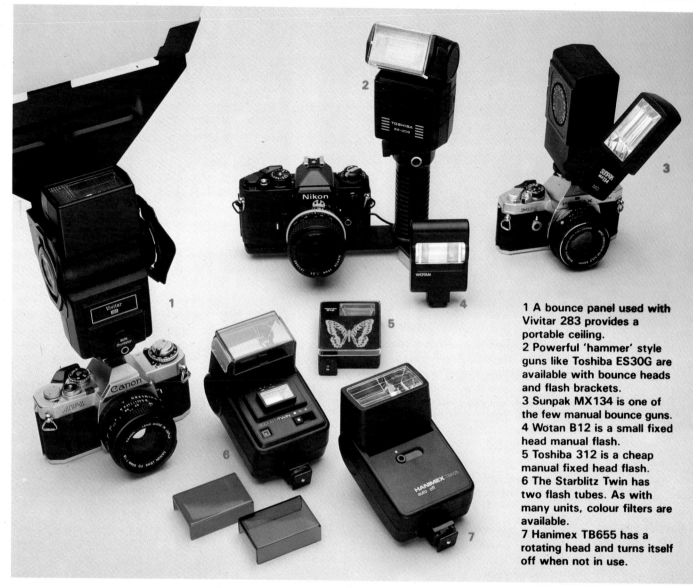

1 A bounce panel used with Vivitar 283 provides a portable ceiling.
2 Powerful 'hammer' style guns like Toshiba ES30G are available with bounce heads and flash brackets.
3 Sunpak MX134 is one of the few manual bounce guns.
4 Wotan B12 is a small fixed head manual flash.
5 Toshiba 312 is a cheap manual fixed head flash.
6 The Starblitz Twin has two flash tubes. As with many units, colour filters are available.
7 Hanimex TB655 has a rotating head and turns itself off when not in use.

Most amateur electronic flash units are designed to be clipped into a camera hot shoe. The flash is therefore in a fixed position close to the lens, and points directly at the subject. The effect of this direct flash invariably produces harsh, flat lighting with heavy shadows on, and behind the subject and perhaps bleached-out highlights. With the flash so close to the lens red-eye effects often occur. The effect is totally unnatural, it is immediately apparent that flash has been used and, particularly in portraiture, it gives unflattering results. Any way in which the light can be diffused dramatically improves the results: shadows are softer and the overall lighting more even. To diffuse light it must be spread out. This can be done either by bouncing it or by dispersing it at source.

Bounce head flash guns
A number of flash guns with bounce heads are available and they provide the means for more interesting lighting effects. Bounce heads make it possible to tilt the flash tube upwards, independently of that part of the gun which connects to the camera, and enables you to reflect the light from the ceiling, for example.

Lighting with bounced flash generally makes portraits more flattering and a view of a room is more evenly and naturally lit without heavy distracting shadows.

Choosing a flash gun
There are very few manual guns with bounce heads so your choice is limited to automatic flash which does cost a little more. Automatic flash guns give one or more aperture settings. The film speed is set on the calculator dial on the flash gun and an indicator of some sort shows the aperture (or choice of apertures). The calculator also shows to what distance the flash gun gives correct exposure at the given aperture. The automatic facility cuts off the flash as soon as the subject has received the right exposure.

This sets you free from complicated exposure calculations and, as long as the flash is correctly set up, you are practically guaranteed a correct exposure every time. This is even more useful when you start varying your flash techniques. However, you may be able to use an ordinary manual gun wired to the camera via an extension sync cable allowing you to direct the flash up towards the ceiling.

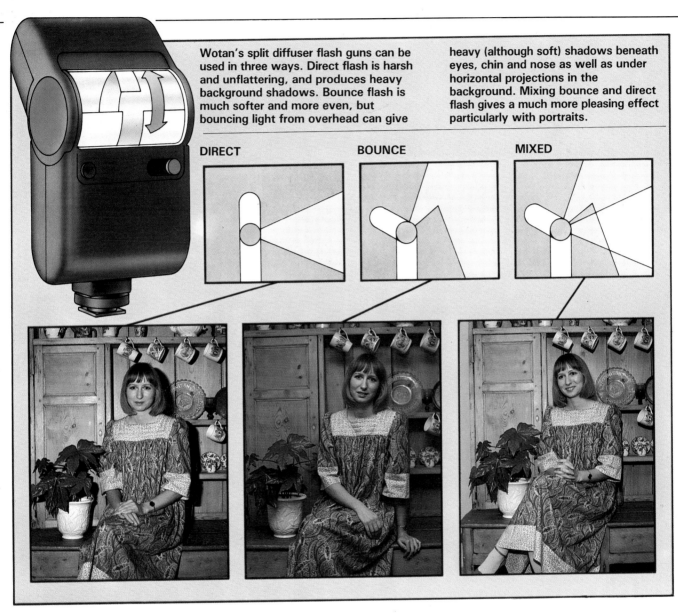

Wotan's split diffuser flash guns can be used in three ways. Direct flash is harsh and unflattering, and produces heavy background shadows. Bounce flash is much softer and more even, but bouncing light from overhead can give heavy (although soft) shadows beneath eyes, chin and nose as well as under horizontal projections in the background. Mixing bounce and direct flash gives a much more pleasing effect particularly with portraits.

DIRECT BOUNCE MIXED

A good alternative is to invest in an angle bracket which allows the entire flash gun to be angled so that light bounces from a chosen surface. Remember to measure the total distance the light has to travel (camera to ceiling to subject for example) and use this information to calculate the correct aperture. Make sure that the light is reflected from the bounce surface at the correct angle to fall on to the subject. If the angle is wrong the results will be poor.

A flash with a guide number (GN) of 20 to 24 (metres at 100 ASA) is powerful enough for bounce flash in a normal sized room. It is also powerful enough for many other types of photography, although spending a little more on GN30 to GN40 allows more versatility in different situations.

All the automatic flash guns can be used totally manually if you want to do so. In this case you have to calculate the appropriate aperture based on total flash to subject distance.

Some bounce head auto guns have a flash confirmation light or 'distance checker' as an added bonus. This indicates that the exposure is correct. Firing the test button in advance of making an exposure saves you wasting a frame if the lamp does not light up—it indicates that you should move the flash closer to the bounce surface, or perhaps select a wider aperture setting.

Practical aspects

Ceilings are usually light in colour and at a suitable height for reflecting bounced flash. But there may be times when the ceiling is just too high for the

▲ Hannimex TS855 has a bounce head which can be used for direct flash or for bounce flash. Using the small auxiliary flash tube with the main tube in the bounce position, mixes bounce and direct flash for better lighting.

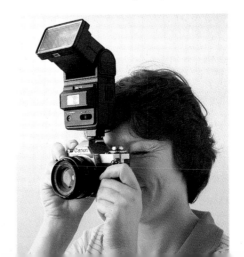

effect you want or for the power of the flash. You can still use the bounce head but substitute a large white card for the ceiling and hold it closer to the flash head. This may cause problems if you don't have someone assisting, although you can work single-handed with a gun which has a built-in bounce panel.

An alternative is to bounce the light from the side rather than overhead. This gives a totally different side-lit effect. You can use a variety of surfaces, whether a wall or a large piece of cartridge paper which someone is holding for you. For this you will need a flash gun with a head which rotates from side to side.

The sensor on an auto flash gun reacts to the overall light it reads. This can lead to over- or under-exposure depending on the circumstances.

● If the background is very light and the subject is close to it, the sensor will under-expose the subject. In this case set the camera one stop larger than that indicated on the flash unit.

The subject will then be correctly exposed even though the background may be slightly over-exposed. The reverse is also possible—if the background is very dark the subject may be over-exposed. Decrease the aperture one stop to that indicated on the flash gun calculator dial.

Portraits need soft lighting if they are to be flattering. If the flash is bounced overhead don't work too close to the subject. If the bounced light comes down directly above the subject, hard shadows around the eyes will show.

● Regardless of whether you are bouncing the flash from overhead or from the side bear in mind that the closer the reflecting surface is to the subject the more contrasty the lighting will be.

● Backgrounds in portraits can be distracting. Stark white backgrounds aren't ideal, nor are patterned backgrounds. To make a background less distracting move the subject as far from it as possible. A white background will then become grey because less light reaches it and a patterned one will be out of focus.

● The colour of the reflecting surface will influence the colour of a portrait just like using a colour filter. This hardly matters when working with black and white but in colour, red and green surfaces could lead to unnatural tones in the resulting photographs.

● If you are using a wide angle lens its coverage may be more than that of the flash gun. If you bounce the light then

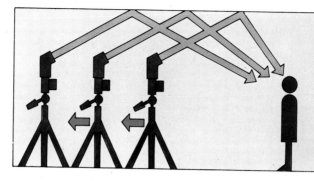

◀ When bouncing flash from a ceiling the effect can be changed by moving the flash nearer to or further from the subject, or by varying the bounce head angle; make sure that the light does not miss the subject.

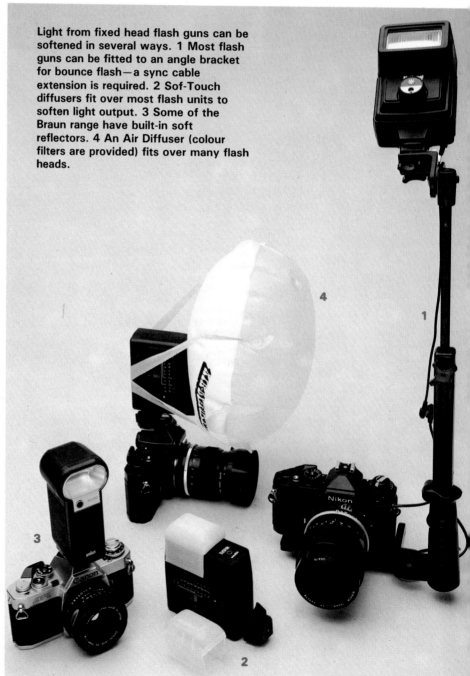

Light from fixed head flash guns can be softened in several ways. 1 Most flash guns can be fitted to an angle bracket for bounce flash—a sync cable extension is required. 2 Sof-Touch diffusers fit over most flash units to soften light output. 3 Some of the Braun range have built-in soft reflectors. 4 An Air Diffuser (colour filters are provided) fits over many flash heads.

the light is sufficiently scattered not to make this a problem. An alternative is to fit a wide angle diffuser over the flash head.

Off-camera flash
Removing the flash from the camera opens up a new world to the photographer. You don't need a special flash gun; all you need is a long synchronization lead to plug into the camera X socket.

Buying a 1m or 2m extension cable allows you to remove the flash from the camera and point it at the ceiling, walls or card to bounce the light at any angle and distance relative to camera and subject. It's best to have the camera on a tripod to leave your hands free. If you use a pneumatic cable release (or the camera's delayed action mechanism) you can even move away from the camera (to hold the reflecting

▼ These Philips flash guns have built-in slave cells, but many other guns can be used with a separate slave cell which makes it possible to use several flashes, all perfectly synchronized with the shutter. Lighting can become far more versatile, and trailing cables around the set-up are avoided. Separate stands and hot shoe adapters are needed for each extra flash in use.

card perhaps). By taking the flash gun away from the camera the exposure will be affected: the sensor on the flash gun will read the light reflected back at it and this is not necessarily the same as that reflected to the camera. For the right exposure switch the flash gun to manual and calculate the aperture on the total distance between the flash unit and the subject.

Using two flash guns
If you have two flash guns they can be used simultaneously. A slave cell is used to fire the second flash gun—one gun must be connected to the camera for synchronization. The slave cell is connected to the second flash gun and is positioned so that light from the flash connected to the camera reaches the cell. When the shutter is fired light from the main flash falls on the cell. The cell gathers this light energy and converts it into a tiny electrical impulse. This fires the second flash virtually instantaneously. With this system there is no need to have wires and cables trailing around the floor. Obviously the second flash gun needs to be supported on a tripod or with a G-clamp. (You can use any number of flash guns as long as each additional flash gun has a slave cell.)

In effect you have a mini-studio system

and can use your lights for far more varied effects than is possible with just one flash. You can use one flash as the main light and the other to fill in heavy shadows or, alternatively, move one flash behind the subject to act as a backlight. In addition you can soften the flash (or flashes) by bouncing it.

Softer direct flash
To save yourself the trouble of working out correct apertures and whether the flash is bouncing at the correct angle you may prefer to use something simpler. Some flash guns have soft reflectors rather than shiny chrome ones and this helps disperse and therefore soften the light. The results are not as soft as for bounced flash.

If you are happy with the fixed-head gun you already own you can soften the light by taping a tissue or handkerchief over the flash head. Soft diffusers are available to clip over the flash. As light passes through the diffuser it is dispersed to give a more pleasant effect.

However you diffuse the light at source the intensity is reduced. An automatic gun will adjust the duration of the flash accordingly, but with a manual flash gun you must open the aperture by about one stop—though do experiment first.

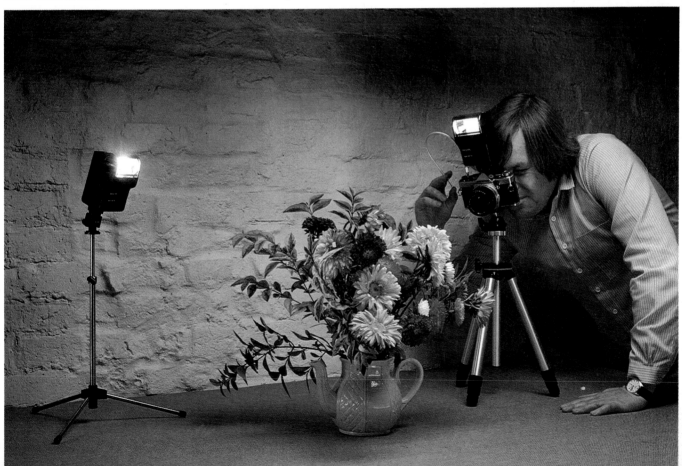

Tungsten lighting

Long before electronic flash was invented tungsten lighting systems were used in many studios. They are versatile, easy to add to and, compared with studio flash systems, tend to be reasonably priced. If you have ever experienced the unpredictable lighting caused by using flash without modelling lights, an economical tungsten system may be the answer. As you move the lights or use different reflectors and diffusers you can immediately see the effects they produce.

'Tungsten lamps' are so called because the basic construction is a thin filament of tungsten contained in a glass envelope—domestic light bulbs are of this type.

Photofloods. There are several types of tungsten lamp, the most common choice for the amateur being a 500W photoflood. The lamp contains a thin filament such as is found in much lower voltage bulbs. When connected to a domestic mains supply the filament glows extremely brightly. These lamps have a limited life.

Photographic lamps. It would be inconvenient for the hard-working professional to change his lamps every few hours and for extended use 'photographic' lamps are preferred: these have standard 500W filaments to provide a longer working life.

Tungsten halogen. A third type of lamp, known as tungsten halogen, is often found in spotlights. The specially designed glass envelope is shaped differently and is smaller than a photoflood or photographic lamp with the same output. The glass envelope contains a halogen gas, such as iodine, which maintains consistent light quality throughout the long life of the lamp because blackening of the inside of the bulb is reduced to a minimum.

Colour effects of tungsten lighting

The quality of tungsten light is much 'warmer' or redder in tone than daylight or flash, and you must therefore use specially balanced tungsten film. An alternative is to use a special correction filter over the camera lens (or in front of the lights, but this tends to be rather expensive).

The only colour negative film balanced

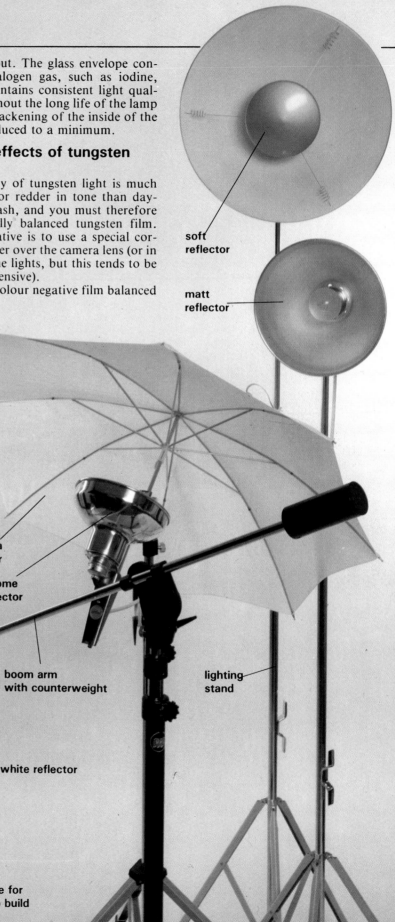

soft reflector

matt reflector

umbrella reflector

chrome reflector

boom arm with counterweight

lighting stand

white reflector

A large number of reflectors and supports are available for use with tungsten lamps allowing the photographer to build up a comprehensive and versatile lighting system.

for tungsten lighting is Vericolor Type L (available in 120 roll film). Kodacolor 400 has subdued sensitivity to red and blue light and acceptable prints may be obtained with tungsten lamps. Tungsten slide film, such as Kodachrome, is balanced for use with photographic lamps and you must use filter 81A over the camera lens when using photofloods. Filter 80B allows use of daylight balanced film with photofloods while filter 80A on the lens permits correct balance with photographic lamps.

Reflectors

Inserting a photoflood into a domestic lamp holder is not recommended because the bulbs become hot after a very short time. In addition this will not allow you to control the light spread and you would be restricted to a bright harsh patch of light to illuminate the subject.

The more lamps and different types of reflector you have, the more versatile the lighting effects can be. But to be practical you can achieve a wide number of effects with just two lamps and two or three different types of reflector.

Soft reflector. To produce diffused, soft-edged shadows, direct light is prevented from reaching the subject by positioning a metal reflective guard over the bulb.

Floods. Placing a deep bowl-shaped polished reflector around the lamp (without a metal guard covering the bulb) provides bright widespread light much harsher in quality than that from a soft reflector. The smaller and deeper the reflector the narrower is the light beam.

Reflector boards. There is no reason why you shouldn't make your own reflector boards. White card or cartridge paper are suitable for bouncing light to give a soft effect, while silvered paper or crinkled aluminium foil stuck to

rigid card gives more sparkle—a slightly less diffused effect. You could make a whole range of sizes to suit different subjects. Angle the light at the reflector so that it falls on to the subject to provide the desired effect.

Umbrellas. Studio umbrellas are more commonly used with flash because it is a cool light source, but if you are careful not to over-heat the 'brollies' they can be a more convenient, easily portable version of reflector boards.

Screens. Proprietary diffusion screens are available but, here again, you can improvise. Tracing paper or translucent plastic stretched over a rigid frame are suitable materials for diffusing light from tungsten lamps. Remember to keep the screen at least 50 cm away from the bulb or it may melt or scorch. Using a screen in this way softens the light according to the distance between screen and subject— the closer the screen to the subject the softer the light quality produced.

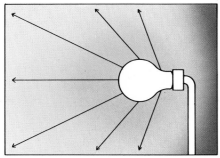

▲ A tungsten lamp without a reflector cannot be used for controlled lighting. Light spreads in all directions is harsh and gives heavy, distinct shadows.

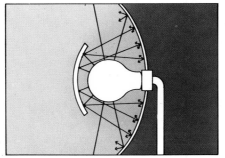

▲ A soft reflector with a baffle over the bulb prevents any direct light from reaching the subject. Lighting is diffused and shadows are soft-edged.

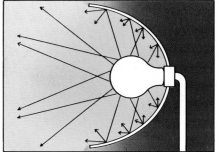

▲ A bowl reflector lights the subject directly and forms distinct, hard-edged shadows. Different diameters and surfaces vary the light effect.

▲ By using a large white card you can make your own soft reflector. Light is reflected from the card and is diffused. This is ideal fill-in lighting.

▲ Aiming the lamp and reflector at the interior surface of an umbrella reflector also diffuses light and gives soft and even lighting.

▲ Placing a diffusion screen in front of the lamp causes scattering of light as it passes through the translucent material and softens the effect.

Spotlights

These fall into a separate category basically because no large reflector is used (it has a small internal one) as this would defeat the object. Just as it sounds, a spotlight produces a narrow beam of light, harsh in quality with distinct shadows, and which you can easily control to light a limited area. Often the beam can be varied in width by focusing the lamp through a fresnel lens in the front of the unit.

A small degree of softening can be produced by clipping a metal grid over the spotlight. There is often a connecting point for filter holders so that coloured spots can be shone on to subject or background and the most sophisticated 'effects spots' allow patterns to be projected on to the background.

Supports

You will need to hold the lamp and reflector off the ground, adjust the height, and angle the light. A number of supports are available. They can be raised and lowered at will, and some have castors allowing the lamps to be repositioned quickly. All stands are available with special lamp holders.

Positioning adapters allow lamp and lamp holder to be clipped to any convenient support such as a table leg or even to a lamp support so you can position the lights wherever you wish.

Using the lamps

Make sure that you have sufficient power points from which to run all your lamps. Most lights will need a considerable length of cable to allow you to move the lights around your 'studio'. A socket bar with three or four plug sockets assembled together with a supply cable plugged into the mains provides a central run-off point. Take care not to trip over the cables—keep them out of the way as much as possible.

● A lighting control socket consisting of square-pin sockets (up to 500W each) can be used to vary light intensity at the flick of a switch. Each socket has an independent on/off switch and full- or half-power settings. But do not shoot on colour film with the lights at half power or a red cast will result—this is only suitable for black and white photography.

● When the lamp is warm the filament is fragile. Only move the lamps if necessary and do so gently or the bulb may blow. Castors give smoother, less traumatic, mobility.

● All tungsten lamps produce heat along with light. This is uncomfortable for a portrait subject and does not do your reflectors much good either. Turn off the lamps periodically to allow them to cool—this is particularly important if you are using a snoot or diffusing screen. Do not, however, turn the power on and off repeatedly and at short intervals. Be careful not to block cooling vents and keep your studio well ventilated for your own comfort.

The main advantages of tungsten light is that financial outlay for a complete system is less than for an equivalent studio flash system. You can see the lighting effect at a glance whereas modelling lights, if the flash system has them, may not equal the power of the flash. Nor do you need to use a special meter as with flash—your camera's meter or a separate hand-held one can be used.

However, one of the biggest disadvantages is the amount of heat produced and the uncomfortable constant glare of the lamps. This may make a human subject fidgety and perhaps dry out still-life specimens. The lamps give less intense light than flash and, in addition, burn power all the time they are switched on.

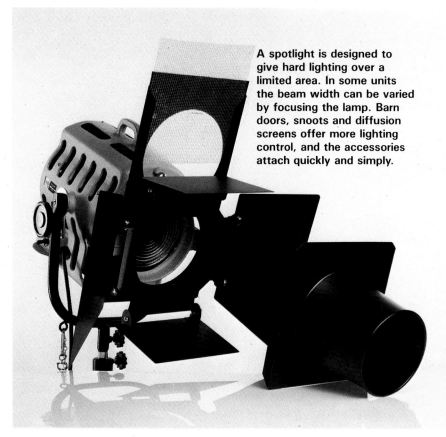

A spotlight is designed to give hard lighting over a limited area. In some units the beam width can be varied by focusing the lamp. Barn doors, snoots and diffusion screens offer more lighting control, and the accessories attach quickly and simply.

▲ The design of a Fresnel lens is particularly suitable for use in a spotlight. It converges the light beam and disperses heat from the lamp.

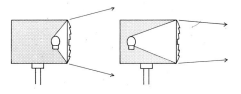

▲ A focusing spotlight lamp allows variation in diameter of the light beam. The broad beam setting (left) gives the hardest shadows.

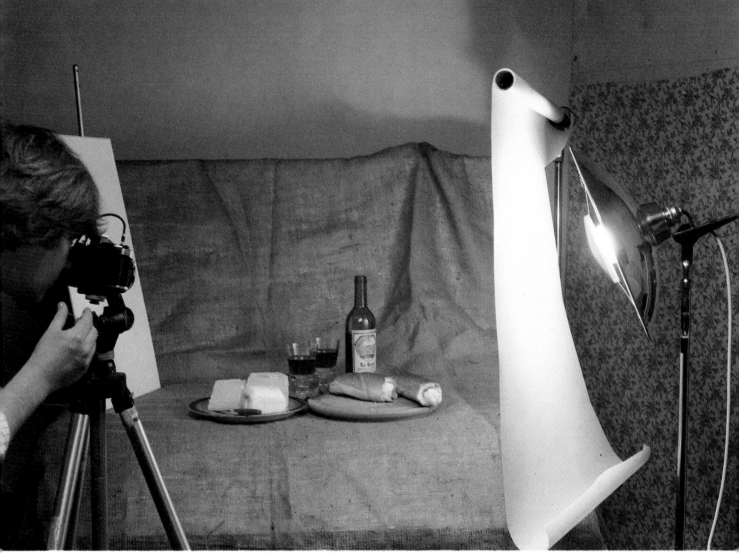

Be safe

● Check that all plugs are correctly wired and adequately fused. Worn or frayed cables and cracked plugs are dangerous.

● Never plug several lamps into an adapter.

● Make periodic checks to connections, especially where cables enter the lamp holder. The constant heat produced by tungsten lamps may make insulation brittle.

● If you run more lamps from your electrical circuit than it was designed for, the cables will overheat and there is a great risk of fire.

● If fuses blow there is obviously a reason for it. Do not replace a blown fuse with one of a higher amperage. If you cannot find the reason for the fuse blowing seek professional advice.

● Never handle electrical appliances with wet hands.

▲ You do not necessarily need a complicated tungsten lighting set-up to photograph still-life successfully. A soft reflector, tracing paper and a fill-in card are extremely effective.

◀ Tungsten lamps are similar in construction to domestic bulbs, but tungsten halogen lamps are longer and narrower.

◀ A high power spotlight element. The coiled spiral reduces the amount of free radiating surface, so increasing the temperature of the filament. However, raising the working temperature of the filament reduces its life.

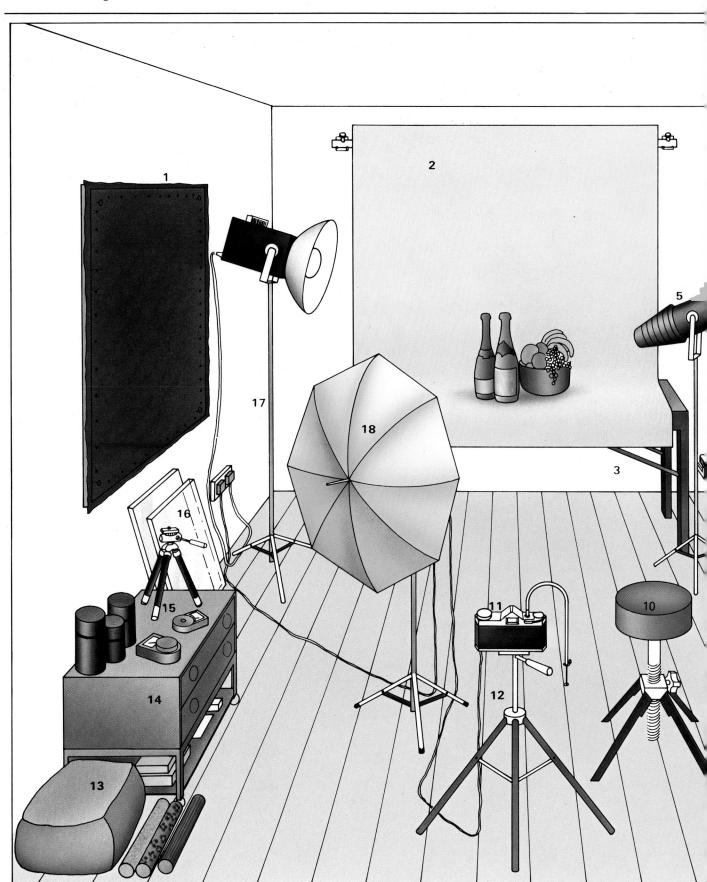

Although daylight will do most of the time there is the occasion when you may want to photograph a still-life, a portrait or do some glamour photography. By working indoors and using artificial light you have complete freedom to work how and when you like—rather than relying on daylight and the vagaries of the weather. Using artificial light and excluding daylight completely gives you total control of lighting effects. (For details of tungsten lighting see page 74; and for flash see page 70.)

The word 'studio' often conjures up visions of a grand room equipped with an expensive battery of lights, cameras and background materials. You may be surprised therefore to find a professional photographer taking portraits, still-life sets and antiques in a studio no larger than a fair-sized living room.

Size of studio

You can improvise a temporary studio in almost any room, even if you live in a small flat. If you are lucky enough to have a spare room then it can perhaps be set aside as a permanent studio.

The only rooms not suitable are those smaller than about 2½ x 3½ metres and those with ceilings lower than 2½ metres. In a small room you are forced to have the lights and camera too close to the subject, and the subject too close to the background. The results are cramped, harshly lit photographs with unwanted shadows on subject and background. At the smallest you could get away with a room 4 metres long by 2½ metres wide, but the ideal width is 3 metres to allow room for backgrounds and lights on either side. The 4 metre length allows you to use a

135mm lens on a 35mm camera for example. This gives good perspective with head and shoulder portraits and allows room to position the background and lights to best advantage.

Blacking out the studio

Daylight streaming through a window swamps the studio lights, whether tungsten or flash, so the studio needs to be blacked out with opaque material fixed over the windows. It is best to use a system which allows you quickly to place and remove the black-out material, and the choices are either a special vinyl material, preferably stretched over a rigid frame slightly larger than the window frame, black roller blinds, or any other flexible opaque material.

Colour of studio

To control light to the utmost the studio should be decorated in neutral colours, such as black or dark grey. White flats (large sheets of white reflective material mounted on a rigid frame, or perhaps huge sheets of polystyrene) can then be used to reflect light on to the subject. Many photographers prefer a white studio, however, because they have a greater choice of reflective surfaces from which to bounce light—perhaps to imitate soft, overcast daylight.

If you are using a room temporarily as a studio and the walls are colourful, rig up sufficient white sheets or flats to prevent unwanted colour casts on your subject.

The floor should be uncarpeted and clear of clutter. The best floor coverings are flat with a pile-free surface, such as vinyl or wood. If you

The ideal permanent studio is located in a fair sized room with pale, neutral walls and a flat pile-free floor.
1 Removable black-out material 2 Wall mounted background paper (other support systems are possible) 3 Collapsible trestle table for still-life subjects 4 Rack for storing large lighting accessories 5 Studio flash unit 6 Various sizes of fill-in cards 7 Background paper (available in other widths) 8 Hot and cold fan heater 9 Glass topped table for close-up work and special lighting techniques 10 Adjustable height stool 11 Camera with cable release (have as many optional lenses to suit your needs as you can afford) 12 Sturdy tripod with pan and tilt head 13 Bean bag cushion 14 Wheeled trolley for storing small

props and accessories 15 Table tripod 16 Glass for still-life sets and mirror for special effects 17 Adjustable height lighting stand 18 Reversible umbrella reflector.

Avoid having a network of cables stretched dangerously across the floor. Install sufficient power points for convenience and safety. Choose a flash or tungsten lighting system to suit your means as well as a range of diffusers and reflectors to permit varied lighting techniques. Don't throw away old pieces of felt, cork, or slate, and keep your eyes open for inexpensive lengths of material—all these items can be used to set the scene for a successful photograph and add an original and professional touch. Good photographers are innovative.

can't move the carpets be careful not to tread on the background paper or it will crease and tear because of the soft flexibility of the carpet's pile.

Backgrounds: special photographic background paper is free from creases and texture, and has high colour saturation. You do not need a whole spectrum of colours—black, white and one or two pastel and bold colours are adequate. Background paper tends to be expensive—persuade a friend to split the cost of a 3m wide roll with you and cut the roll across its width.

You can equally successfully use carefully ironed lengths of plain-coloured material (bought as off-cuts at the local market) or painted sheets of hardboard. Plain velvet curtains also lend themselves beautifully as backgrounds.

Studio equipment

You do not need to buy expensive professional equipment; success relies mostly on innovation. Basically you need items to put the structure of the picture together—to hold the background, lights and camera in the right positions.

Supports: lightweight aluminium tubing with push-fit plastic joints,

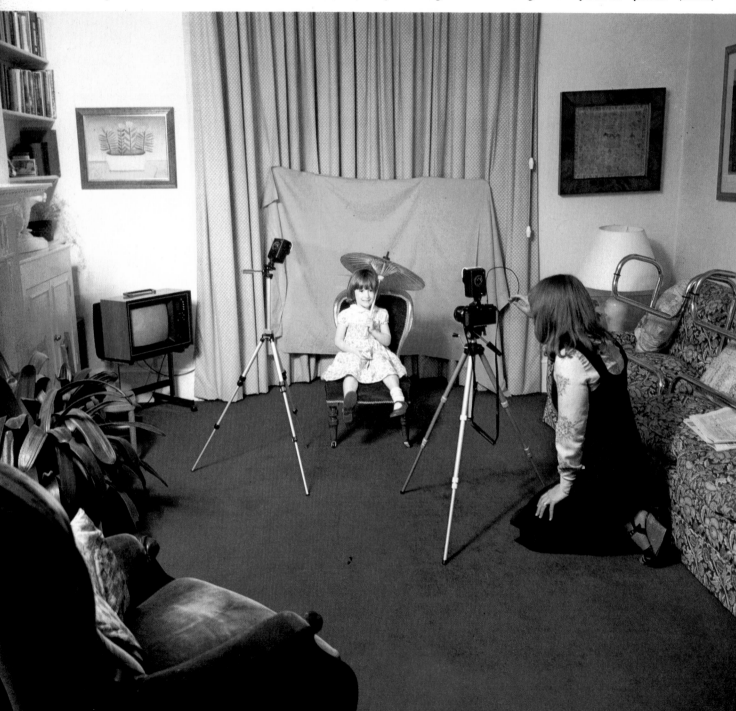

hinges and feet, is available from agricultural wholesalers. You may prefer a heavier system with steel tubing and screw clamps including camera mounts and lighting adapters, or for small lamps you may be able to use microphone stands—although special lighting stands are comparatively inexpensive. Good quality Bakelite lamp holders are perfectly good to

◄ A temporary studio can be quickly set up without disrupting the house. Move enough furniture to provide clear floor space around you and the subject, and leave room for the background. Equipment can be as simple or complex as you wish to make it.

► When using props to help you with a difficult subject, such as an infant, make sure to choose something which complements both mood and composition. *John Garrett* chose a colourful toy.

▼ This portrait was taken in the improvised studio illustrated (left) using two flash guns with built-in slave units. A piece of stocking over the lens gave a soft focus effect.

use with photofloods—they must be wired to the mains with heat-resistant silicon-rubber cable.

Two lighting stands can be used to hold a roll on which your background paper is supported. A U-shaped trough is also available to hold background rolls on a single stand. The same type of lighting stands are, of course, used to support tungsten and electronic flash units, and you can buy adapters for hand-held flash guns.

Buy a sturdy tripod for your camera. This allows you to stand away from the camera which often makes a human subject more at ease. Use a cable release to fire the shutter.

Props: a small, wheeled trolley with drawers and shelves can be used to house handy bits and pieces, such as double-sided tape, a stapling gun to secure backgrounds, drawing pins, cans of spray paint, bulldog clips and G-clamps as well as a supply of film, a set of filters, lenses and several small camera accessories.

Two or three adjustable height stools are useful for model and photographer. A stool on wheels allows the photographer to change position easily. You will also need a small table (preferably a collapsible trestle type for easy dismantling) and a large sheet of glass for still-life. If you photograph children a

few toys and bean bag cushions are a boon, and keep various sizes of white fill-in cards on hand.

A large mirror can be used as a prop or to add a 'hair light' if there is insufficient room behind the subject to place a lamp. The mirror must be positioned carefully to reflect back one of the main lights on to the subject's hair without the mirror showing in the shot.

Power

For ease of working a studio must have enough power points to, allow a number of lamps to be positioned to create the best effect. A cable stretched across the room or four plugs in one adapter are dangerous.

Tungsten lights: if you intend to use a number of tungsten lights remember that 2000W halogen lamps, 1000W spot lights and 500W photofloods quickly add up to the full capacity of a fuse in a plug, and a tungsten system, especially if you use other electrical appliances such as a fan heater, may require a separate 30 amp ring main. Apart from being dangerous, ignoring this may be against conditions of tenancy, lease or electricity supply.

Electronic flash: this consumes less power for effective light output, and of course battery operated guns make no demands on your domestic supply. If you use studio flash with modelling lights, or add modelling lights to small

units, this will burn more power but the modelling lights are usually no more than 275W each.

Tungsten lights generate heat, and a busy session soon warms up a small studio. But when using flash you should have some form of heating to keep you and your model warm. If the lights are used only periodically you should maintain minimum temperature of around 10°C, to avoid rust or, even worse, condensation inside electrical units. A portable fan heater which blows cold as well as hot air will be helpful for summer and winter photography sessions. Never use a paraffin or gas heater in an enclosed room with poor ventilation facilities.

▲ This still-life was set up to produce a master negative for a colour analyser, using the grey scale as a reference point. To provide reliable information for analysis the card was lit in the same way as the subject.

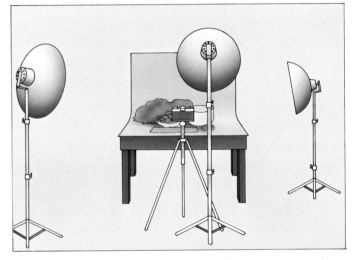

▲ Bright, even illumination was provided by three tungsten lamps. A large bowl reflector to the right of the subject provided modelling, and two large soft reflectors produced diffused frontal and side fill-in illumination.

▲ A dark background and a dark-haired model were *Michael Busselle's* natural choice to create a mysterious mood. To maintain the atmosphere a simple lighting technique was used to give soft illumination.

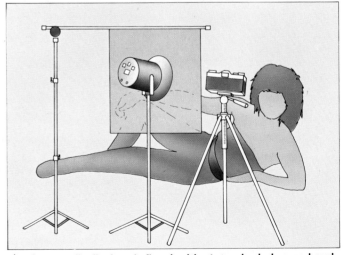

▲ One studio flash unit fitted with a standard chrome bowl reflector was positioned close to the camera and angled slightly downwards. A piece of tracing paper over the flash head softened light from the flash.

Daylight

Daylight can be used, especially if the room has a large north-facing window (south in the southern hemisphere) or a diffused skylight and if the décor is light and neutral. To make the best use of daylight you need two or three large reflector flats on stands, or white cartridge paper or crumpled kitchen foil pasted to stiff card. These are used to direct fill-in light.

● If you are using black and white film mixing light—daylight and tungsten for example—is possible. If you want to mix daylight with tungsten using colour film you must cover the windows with special sheets of orange-brown filter plastic to balance the two types of light and use tungsten balanced film.

If you don't want to go to the trouble of setting up a studio, whether temporary or permanent, choose a room with sufficient clear wall area and enough room for you to move around.

▲ **(Left) Late evening sunlight gives a pleasantly warm effect, but such directional light sources produce heavy shadows. The side of the face next to the window is well lit, but the other side is cast into heavy distracting shadow. (Right) To improve portraits using daylight from a window some form of fill-in is necessary to provide shadow detail and to balance the lighting effect. Both needs have been met and the warm quality of the scene is maintained with a simple technique.**

▶ **If you use daylight in your studio then you can fill shadows by reflecting light back on to the subject. Ask an assistant to hold a large white card, or support it on a suitable stand.**

You may have the sort of living room that lacks clutter and which makes a good studio set without shifting furniture or having to make other special arrangements.

Slide mounts and magazines

After commercial processing, slides are mounted in card or plastic frames. These do not offer much protection to the actual slide although they keep the slides uniform and suitable for projection. Glass mounts are preferable as they completely cover the slides, keeping them clean and free from scratches. But glass mounted slides have one disadvantage—if the glass breaks the slide will probably be ruined. Therefore never send slides in glass mounts through the post.

There are various ways of keeping and storing slides. Obviously if you intend projecting them they must be mounted in frames. As your collection of slides increases, it becomes more important to have some sort of filing system so that you can find any particular slide

you may want. It is therefore essential to caption each slide—do this as soon as the slide is processed, otherwise you may forget what the picture is. Indexing the slides depends on how large your collection is, the sort of photographs you take and the amount of detail you require. Label each magazine or number it and keep a separate record of its contents.

Slide mounts

Slides are usually returned to you from processing mounted in card or plastic mounts, and most people find these acceptable. But the slide is not firmly held and it can 'pop' from the warmth of the projector, causing it to go out of focus as the film expands and curves in the mount. With remote focus projec-

▲ Sorting slides is made easy with an illuminated slide sorting tray. An eyepiece allows for critical appraisal of the quality of a slide.

tors you have to correct the image; auto-focus projectors have a moment of unsharpness before sensors catch up and change the setting, although they sometimes fail to do this.

To overcome the problem completely, you need to sandwich the slides between glass. Glass mounts are readily available and must be handled with care: brush dust away and avoid fingerprints on the glass when mounting the slides. The result is a permanently protected slide which will not fade or 'pop' in the projector.

Newton's Rings: coloured light rings

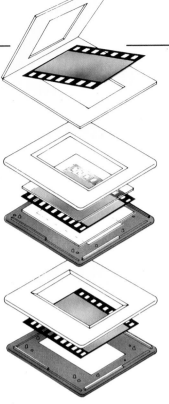

▲ Slide mounts can be card or plastic. Plastic ones are available with and without glass.

▼ Slide mounting jigs snap plastic mounts together. The larger jig has an illuminated panel to ensure accurate alignment of the transparency.

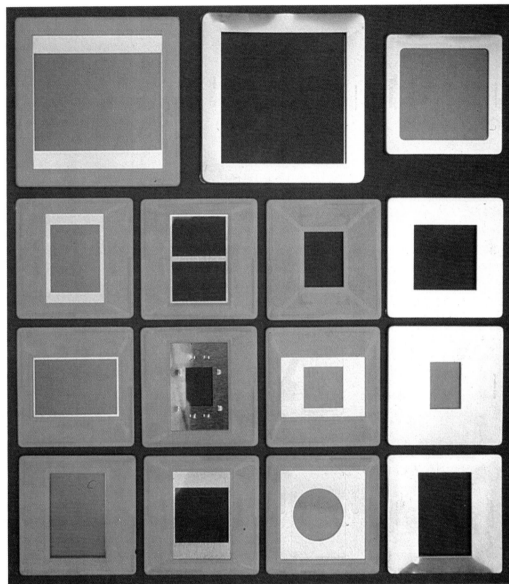

▲ Slide mounts are available in a variety of shapes and sizes. The different shapes are used to crop or mask unwanted picture area.

may appear on a projected slide. This happens when a slide is glass mounted and the glass is making partial contact. Some frames are designed to prevent this from happening.

Projecting slides

All slides are inserted into a projector with the emulsion side of the film facing the lens and the picture upside down. The emulsion side is usually dull or has some slight relief on the image while the other side, facing the light source, is shiny. If in doubt, look at the picture so that it reads correctly, facing

the screen, and then insert it into the projector upside down without turning it round, keeping the correct side facing you.

● To help recognize which way up the slides should be inserted, stick small circular stickers on the top right-hand corner of each slide when it is in the projection position (the bottom left-hand corner when viewed by eye). A great help in sorting slides is some sort of viewing aid. Either a light box or a hand-held viewer will do.

● If the slides are to be kept in a particular sequence, draw a diagonal line, from corner to corner, on the outer edges of the slides in the magazines. It is then easy to see if any slides are in the wrong position.

Magazines

Slides can usually be stored in their boxes as returned by the processor, but then they need to be arranged every time you want to project them. Spare magazines are available for projectors. They are a convenient way of storing any number of slides and the magazines can be put directly into the projector—so there is no need to transfer slides laboriously every time you want to project them. Depending on the sort of magazines you are using, you can use transfer trays for your slides. These allow you to invert the slides into the

Magazines for 35mm slides

Magazine type	Capacity	Storage method
DIN standard straight magazine: Agfa, Leitz, Rollei, Chinon, Kindermann, Zeiss Ikon, many others	30, 36 or 50	In magazines, usually two per stacking storage box In 'transfer trays' which are placed over magazine and inverted to load up in one action
DIN standard rotary	100 slides	In magazine
GAF Rototray	100 slides	In magazine
GAF straight magazine	36 slides	In magazine
Hanimex etc straight magazine	36 slides	In magazine
Hanimex etc rotary	120 slides	In magazine
Carousel 80	80 slides	In magazine Transfer tray

magazine quickly and easily.

Some projectors, such as Chinon, accept both the DIN standard magazines which are now almost universal and also GAF or Hanimex type straight or rotary magazines, using an adapter which allows either system to be chosen. Apart from magazines there are other storage systems.

Cellophane sleeves: if slides are not mounted, or are in card mounts and are being handled, keep them individually in cellophane sleeves to prevent them getting covered with fingerprints.

Transparent plastic sleeves are available to hold a number of slides. The sleeve can be filed either in a filing cabinet, in a box file or in an album. The sleeves are useful as they can be placed directly on a

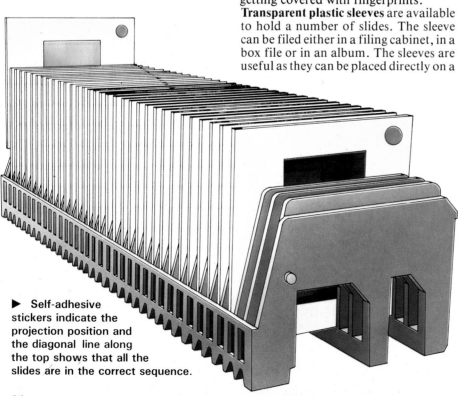

▶ Self-adhesive stickers indicate the projection position and the diagonal line along the top shows that all the slides are in the correct sequence.

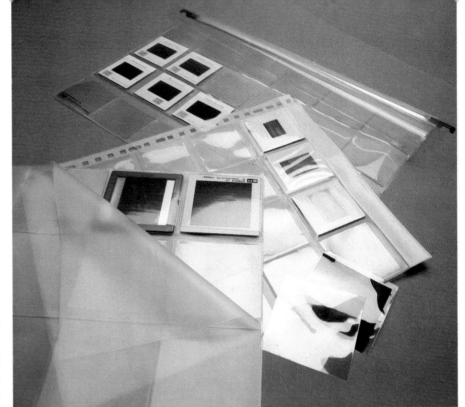

light box to view a number of transparencies at once.

Are slides permanent?

Some people worry about how much they can project their slides. Tests conducted with several popular types of film based on running a set of slides for 10 hours a day through a 250w projector for three months—total projection time per slide 15 hours—revealed the following: Kodachrome slides had faded badly, but those in glass mounts were much better than the card mounted ones. Ektachrome slides had not all faded but some had. Agfa slides were hardly affected. Fuji remained unchanged. Sakura remained unchanged. Ten hours a day is a very long time, and if slides are stored in magazines with protective boxes, there should be no chance of any real colour change.

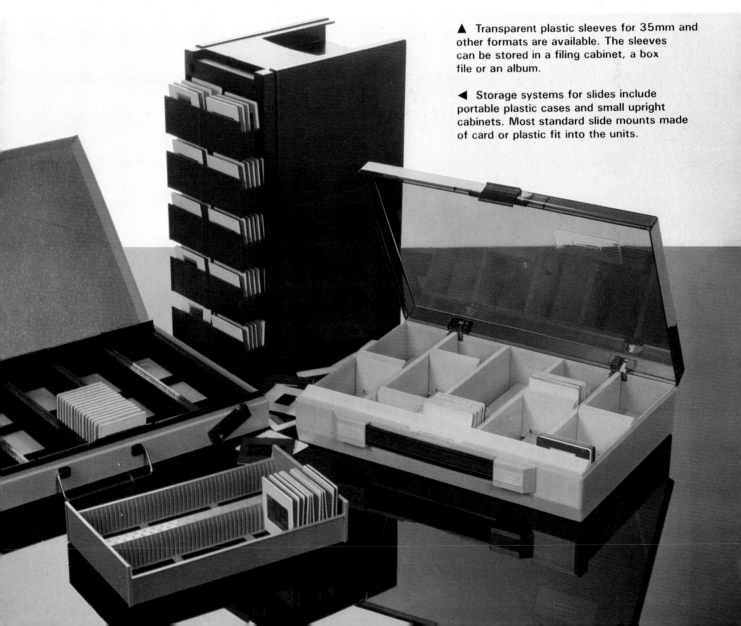

▲ Transparent plastic sleeves for 35mm and other formats are available. The sleeves can be stored in a filing cabinet, a box file or an album.

◄ Storage systems for slides include portable plastic cases and small upright cabinets. Most standard slide mounts made of card or plastic fit into the units.

Projectors and screens

A projector allows you to view your slides in detail and enlarged many times, and for a group of people to view the slides at the same time, making it possible for the whole family to join in and relive holiday experiences. To be successful a slide show needs interesting pictures correctly exposed—don't be tempted to show the duds, set them aside as there is nothing more boring than sitting through lengthy descriptions of what the picture should have been. Get your facts right so that you know where or what each picture is—viewers are bound to ask the odd question and if you make the information interesting, so much the better.

How projectors work

All slide projectors are basically similar. Like photographic enlargers, they consist of an arrangement similar to a camera with the film (now developed) lined up with a lens. A light source is positioned behind the film so that instead of light coming in through the lens to make a picture, it shines through it to recreate that picture on a screen. It is a direct reversal of the light path of a simple camera.

Because there is no sensitive material involved, projector lenses do not need any kind of exposure control, such as shutters or aperture stops, but they do need to be able to focus, so that the screen can be at any chosen distance to get different sizes of the projected picture. Projector lenses are therefore mounted in plain tubes, often with a helical thread which screws in and out of the projector for focusing.

The film carrier could in theory be the same as on a camera, taking a roll of slides, but handling filmstrips is very inconvenient if you want to select the best images, or pick slides from different batches. Filmstrips are also very vulnerable. To overcome this, card or plastic mounts are used to hold each frame individually with enough room to pick up the slide without touching the image area. For 35mm, these measure 50 x 50mm. Projectors must, as a result, have a transport mechanism which can remove one mounted slide from the lens rear and then insert another.

Some projectors have a built-in editing tray. This is a small illuminated rectangle where one slide at a time can be checked before insertion into the magazine. Others have a small illuminated panel in the hand control for this. The light in a projector must be per-

Types of 35mm projector				
Type	**Slide-change**	**Focusing**	**Light source**	**Lenses**
Basic	Single slide manual in push- and-pull carrier or filmstrips	Limited	240v 150w 100w 50w	Fixed 85mm 100mm
Semi auto magazine	Slides in magazines of 30, 36, 50, changed by single action	Full range manual	24v 150w	Fixed or changeable
Autochange remote control	Slides in magazine of 30 – 50 changed by remote hand control button	Full range manual	24v 150w	Changeable 85mm f2·8 standard
Autochange and focus	As above, but extra button on hand set adjusts focus	Manual or remote	24v 150w	Changeable 85mm f2·8 standard
Autofocus	Remote slide change but focus set automatically each time slide changes	Manual or fully auto	24v 150w	Changeable 85mm f2·8 standard
Autofocus rotary	As above but accepts rotary magazines	Manual or fully auto	24v 150w	Changeable 85mm f2·8 standard

These specifications are quoted for clearly identifiable types of projector to which most popular makes adhere.

fectly even and bright. It is projected from behind the slide so that the illumination on the screen extends right into the corners giving a brilliant image, with high contrast and colours, and without hot spots. This demands the use of a condenser system to collect and direct the light accurately.

The intense heat created by the very small tungsten halogen low voltage bulbs, run by a transformer in the projector, must be cut down by a special infra-red absorbing glass filter, or else slides would curl up and plastic mounts melt. To keep the whole system cool, a motorized fan is fitted, blowing air over the bulb and slide area, and this motor is also used in many current projectors to operate a mechanical system for changing slides. The most expensive aspect of projecting is often replacing the bulbs, which normally last 50 hours, but may go after half that time of running.Some projectors have a dimmer switch for low-level out-

put from the bulb. This is not just to compensate for thin transparencies—it increases the life of the bulb to 500 hours.

Further necessary features on nearly all 35mm projectors include some sort of angle adjustments and levelling

▶ **1 Rollei P360 Autofocus takes straight magazines with up to 50 slides. It has a preview screen and handy sloping control panel. Slide change is manual or automatic.**
2 Kindermann AV-100 has built-in back projection screen for table-top viewing. It takes a 100mm lens for conventional projection. Slide transport and focus are remote control.
3 La Ronde Hanomatic EFT has cordless remote control from an infra-red handset and includes a single slide editor and preview screen.
4 Leitz Pradovit CA2500 has automatic focus, interchangeable lenses and a very quick slide-change device.

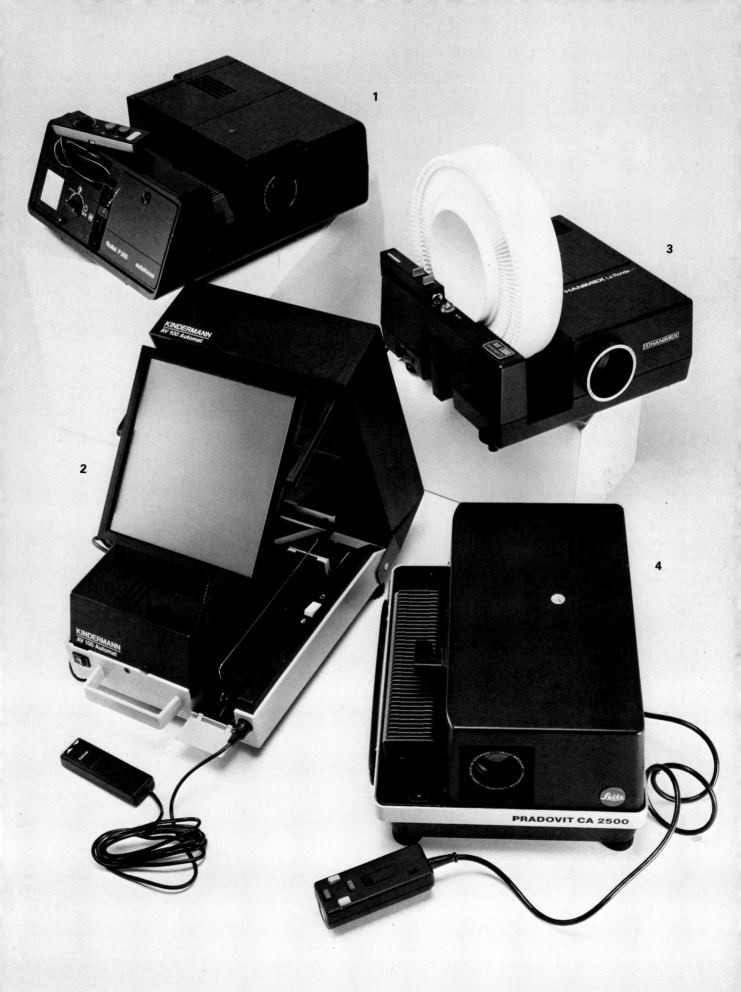

▲ A projector stand gives a comfortable working height. It raises the projector sufficiently to project over people's heads. A shelf below the projector platform is useful for holding spare magazines and storage trays.

screws, so that books don't have to be piled under the front to raise the height of the image on the screen.

The danger of using a pile of books is that, if the projector is at too steep an angle, the auto-shift mechanism may jam. Don't prop the projector higher than the built-in feet allow. There is also provision for removing and changing the lens, so that if you are projecting in a very small space a wide angle type can be used, and for large lecture halls a long throw lens.

Lenses

Projectors for 35mm slides are normally fitted with an 85mm f2·8 standard lens (the aperture may vary from one manufacturer to another). For large rooms, a 135mm or 150mm lens can be used, and for small rooms, a 60mm or 50mm lens. Many projectors can be bought fitted with a zoom lens which is capable of working in almost any size room and costs little more than the standard lens (a small extra on the price of the projector).

Other projectors

Projectors are not confined to 35mm slides. There are some makes for projecting 110 slides, which share the features of the 35mm ranges—from basic to autofocus rotary magazine models. They generally resemble scaled-down 35mm models. For larger format users, there are a few models available. These too can have full autochange and remote focus options, but in this case are very expensive and look like large versions of 35mm models. There are a few projectors available that handle 6 x 6cm transparencies as well as the smaller 35mm ones.

Projector stands

A good projector stand is useful, as they are normally much higher than coffee tables or other household furniture used as stands. They match up to the centre of a standard 100cm screen, meaning you do not need to buy a screen with 'keystone' correction. You can also buy a stand with an adjustable angle on the projector platform plus a second platform in the middle to hold your spare slides or magazines.

Accessories

The only accessory you may find useful for projection is a light pointer—some projectors have these built into their remote hand controls. The pointer projects an arrow-shaped light focused on the screen, so you can point out parts of a picture without putting your hand across the lens to cast a shadow. A film strip attachment is available for some projectors. This allows 35mm filmstrip to be projected.

Viewing aids

There are various viewing aids available so that you can look at your slides without having to set up the projector. This is useful when you receive a batch of slides and want to have a quick look through, when viewing slides on your own or when sorting and arranging slides for a showing. You can just hold them up to the light but this does not allow for critical appraisal of the image as little detail can be seen.

An eyepiece is the cheapest and simplest aid. It acts as a magnifying glass and all you do is hold the slide up to a light source and look at the picture through the eyepiece.

An editing tray, such as a light box, consists of a glass panel with a light behind it. You put the slides on the box to view them. This is best used in conjunction with an eyepiece as you

▲ Although filmstrips are not usually associated with slide projectors, adaptors are available, making it possible to project the strips.

▶ Editing trays for sorting slides.

▼ Viewing aids for sorting and editing slides range from a simple eyepiece which is held up to the light for viewing, to battery and mains operated viewers.

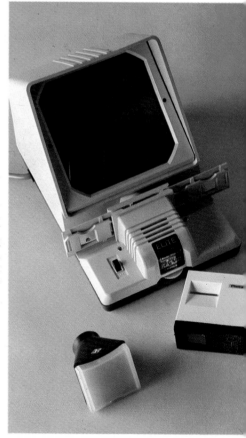

can then see quite clearly how sharp the image is. The light box is useful for getting a quick overall view of a number of slides.

Hand-held viewers have a glass panel with a light source behind. They work on batteries and give a reasonable picture. Slides are inserted manually, one at a time, and only one person at a time can view the slides.

Screens

Most projector screens for popular use are generally available in sizes ranging

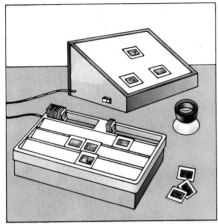

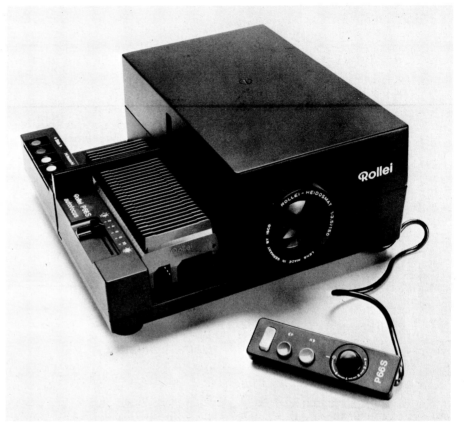

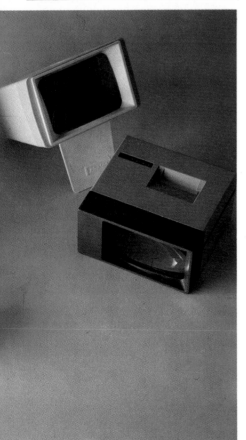

from 100cm square to 177cm square. The reason for the square format is to accommodate both horizontal and vertical 35mm slides. Most screens are on free-standing tripods with adjustable height, but some are designed to stand on tables or to be fixed to the ceiling and pulled down when needed. Good screens have a 'keystone' correction which enables the screen itself to be tilted downwards at anything from 5° to 15°, so that when the projector is sitting on a normal height of table and aimed upwards, the screen can be made parallel to it. This keeps the picture rectangular instead of taking on a 'keystone' shape with the top broader than the bottom.

Screen surfaces determine the cost more than anything else.

Matt white allows you to project in a darkened room, and people sitting almost anywhere can see the picture properly, though it is not really very bright in overall terms.

Beaded surfaces use thousands of tiny glass beads to reflect the light back directly, so you do not need such a dark room, but people must not sit more than 40° off the axis between projector and screen.

Pearl beaded screens, which do not use glass beads but other methods of coat-

▲ The Rollei P66S Autofocus takes 30 6 x 6cm (or 4.5 x 6cm) slides. It has remote control focusing, slide advance and interval timer. After the basic manual focusing, the Autofocus system takes over for sharp projection.

ing, are a compromise. Genuine glass beaded screens can become very brittle after a few years and are extremely hard to clean.

Silvered screens give a very high brightness but you really don't see anything unless you sit within 20° on either side of the projector.

High gain screens use a combination of silvering and glass beads to produce an incredibly bright image. They cost a great deal but some do not allow any deviation from a narrow viewing band area in line with the projector.

Back projection screens are small, about 60 x 91cm, in frames, and can be used in daylight, with the projector shining the picture through the screen so that you view it from the other side. The slides must be inserted backwards for correct viewing.

Choosing screens and lenses

To decide what lens and screen you need, first measure the room where you intend to do most projection.

Measure from the point where you can plug in the projector to the best screen position.

● To calculate the screen size and a suitable lens, proceed as follows. If you would like to use a 100cm screen, you will be blowing up the slide from its 35mm width to 100cm, which is an enlargement of 28 times.

Divide your available distance by 28 and you get the focal length of lens which fills it. If the available distance is about 2·3 metres, you need an 85mm lens. This is not a totally accurate cal-culation—for projecting distances and screen sizes, see below.

● Note that with an 85mm lens in a living room with only 3 metres clear-ance, anything bigger than a 127cm screen would be a waste of money unless you bought a wide angle as well.

SCREEN SIZES AND PROJECTION DISTANCES

SCREEN SIZES		100 x 100cm	120 x 120cm	127 x 127cm	150 x 150cm
Format	Lens	Projection distance in metres			
35mm	50mm	1.5	1.8	1.85	2.2
	85mm	2.5	2.9	3.0	3.7
	120mm	3.5	4.2	4.4	5.2
	150mm	4.4	5.2	5.5	6.5
6 x 6cm	150mm	2.6	3.1	3.3	4.0
	200mm	3.5	4.2	4.4	5.2
	250mm	4.4	5.3	5.5	6.5

▶ The Leitz Pradovit A projector can be combined with a cabinet so that slides are projected on to the back of the screen. The cabinet does not have to be used in a darkened room.

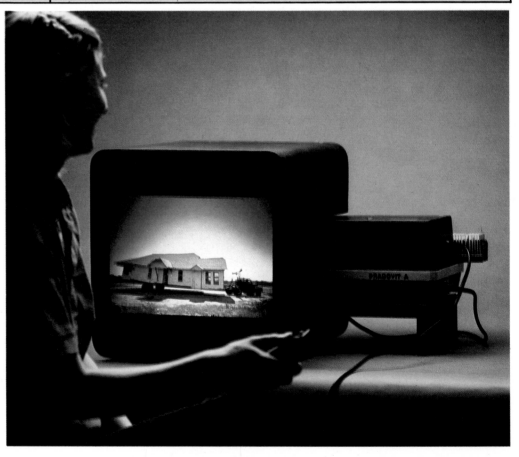

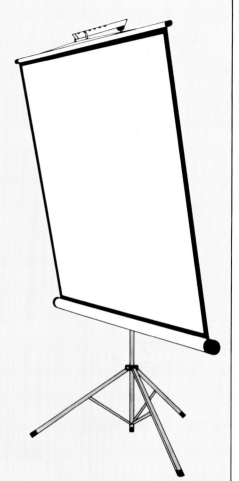

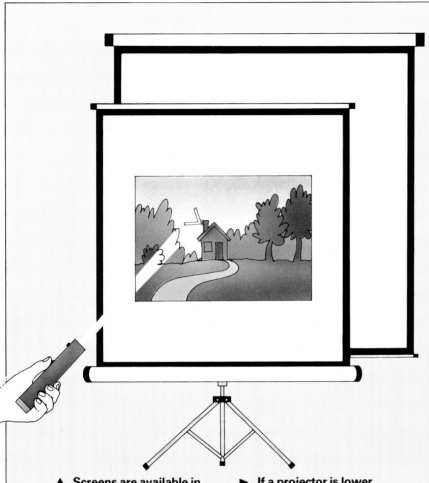

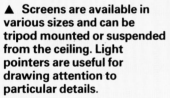

▲ Screens are available in various sizes and can be tripod mounted or suspended from the ceiling. Light pointers are useful for drawing attention to particular details.

▶ If a projector is lower than the centre of the screen the picture will be distorted. A screen with 'keystone' correction, that is it hangs at an angle, prevents this distortion.

◀ The darker a room is the more brilliant the projected image appears. To see the image at its best the audience should be within a certain angle of the screen. The angle depends on the screen surface. Beaded screens have a wider angle of view than silvered screens.

Glossary

Words in *italics* appear as separate entries.

A

Afocal lens An optical unit which, when combined with the main camera lens, changes the focal length.

Aperture The circular opening within a camera lens system that controls the brightness of the image striking the film.

Aperture priority See *Automatic Exposure.*

ASA American Standards Association. The sensitivity (speed with which it reacts to light) of a film can be measured by the ASA standard or by other standards systems, such as DIN. The ASA film speed scale is arithmetical—a film of 200 ASA is twice as fast as a 100 ASA film and half the speed of a 400 ASA film. See also *ISO.*

Automatic exposure A system within a camera which automatically sets the correct exposure. There are three main types:
1 Aperture priority—the photographer selects the aperture and the camera selects the correct shutter speed.
2 Shutter priority—the photographer selects the shutter speed and the camera sets the correct aperture.
3 Programmed—the camera sets an appropriate shutter speed/aperture combination according to a pre-programmed selection.

Auto-winder A unit which can be attached to many SLRs for motorized single frame film advance. After each exposure the auto-winder automatically advances the film to the next frame and cocks the shutter.

B

Bayonet mount A type of fitting on lenses, extension tubes, and other attachments which enables them to be quickly and easily mounted to the camera body.

B camera setting A shutter set to B remains open as long as the shutter release is depressed.

Bracketing To make a series of different exposures so that one correct exposure results. This technique is useful for non-average subjects (snowscapes, sunsets, very light or very dark toned objects) and where film latitude is small (colour slides). The photographer first exposes the film using the most likely camera setting found with a light meter or by guessing. He then uses different camera settings to give more and then less exposure than the nominally correct setting. An example of a bracketing series might be 1/60th sec f8, 1/60th sec f5·6, 1/60th sec f11, *or* 1/60th sec f8, 1/30th sec f8, 1/125th sec f8.

C

CC filters These are 'colour correcting' or 'colour compensating' filters which may be used either in front of the camera or when printing colour film, to modify the final overall colour of the photograph. Their various strengths are indicated by numbers usually ranging from 05 to 50. Filters may be combined to give a complete range of colour correction.

Colour negative A type of film which is used primarily to give colour prints; although colour transparencies and black and white prints may also be produced.

Colour reversal A colour film or paper which produces a positive image directly from a positive original. Thus a colour reversal film gives a colour transparency directly from the original scene and a colour reversal paper, like Cibachrome or Ektachrome paper, gives a positive print directly from a transparency. Most colour reversal materials are identified by the suffix 'chrome'.

Colour temperature Different white light sources emit a different mixture of colours. Often, the colour quality of a light source is measured in terms of colour temperature. Sources rich in red light have a low colour temperature—for example, photofloods at 3400 (Kelvin)—and sources rich in blue light have a high colour temperature—for example, daylight at 5500K. Colour films have to be balanced to match the light source in use, and films are made to suit tungsten lamps (3200K) and daylight (5500K).

Conversion filter Any filter which converts one standard light source to another standard light source. For example, a Wratten 85B filter converts daylight to photoflood type illumination.

D

Daylight colour film A colour film which is designed to be used in daylight without or with electronic flash or blue flash-bulbs. This film type can also be used in tungsten or fluorescent lighting if a suitable filter is put in front of the lens or light source.

Depth of field The distance between the nearest and furthest points of the subject which are acceptably sharp. Depth of field can be increased by using small apertures (large f numbers), and/or short focal-length lenses and/or by taking the photograph from further away. Use of large apertures (small f numbers), long focal-length lenses, and near subjects reduces depth of field.

Depth of field preview A facility available on many SLR cameras which stops down the lens to the shooting aperture so that the depth of field can be seen.

Differential focusing The technique of using wide apertures (small f-numbers) to reduce depth of field, and to therefore separate the focused subject from its foreground and background.

DIN Deutsche Industrie Normen. A film speed system used by Germany and some other European countries. An increase/decrease of 3 DIN units indicates a doubling/halving of film speed, that is a film of 21 DIN (100 ASA) is half the speed of a 24 DIN (200 ASA) film, and double the speed of an 18 DIN (50 ASA) film. See also *ISO.*

E

Emulsion speed See *ASA* and *ISO.*

Exposure factor The increase in exposure, normally expressed as a multiplication factor, which is needed when using accessories such as filters, extension tubes, and bellows.

F

Fast films Films that are very sensitive to light and require only a small exposure. They are ideal for photography in dimly lit places, or where fast shutter speeds (for example, 1/500) and/or small apertures (for example, f16) are desired. These fast films (400 ASA or more) are more grainy than slower films.

Film speed See *ASA, DIN* and *ISO.*

Filter Any material which, when placed in front of a light source or lens, absorbs some of the light coming through it. Filters are usually made of glass, plastic, or gelatin-coated plastic and in photography are mainly used to modify the light reaching the film.

Fisheye lens A lens that has an angle of view greater than 100° and produces distorted images—lines at the edges curve inwards. Fisheye lenses have an enormous depth of field and they do not need to be focused.

Flash synchronization The timing of the flash to coincide with the shutter being open. For electronic flash synchronization it is necessary to use the X sync connection and a suitable shutter speed—usually 1/60 sec or slower for focal plane shutters and any speed for leaf shutters. Flashbulbs are used with M sync and a speed of 1/60 sec (preferable), or with X sync and a speed of 1/30 or slower.

f numbers The series of internationally agreed numbers which are marked on lenses and indicate the brightness of the image on the film plane—so all lenses are focused on infinity. The f number series is 1·4, 2, 2·8, 4, 5·6, 8, 11, 16, 22, 32 etc—changing to the next largest number (for example, f11 to f16) decreases the image brightness to $\frac{1}{2}$, and moving to the next smallest number doubles the image brightness.

Focal length The distance between the optical centre of the lens (not necessarily within the lens itself) and the film when the lens is focused on infinity. Focal length is related to the angle of view of the lens—wide-angle lenses have short focal lengths (for example 28mm) and narrow-angle lenses have long focal lengths (for example, 200mm).

I

Interchangeable lens A lens which can be detached from the camera body and replaced by another lens.

ISO International Standards Organization. The ISO number indicates the film speed and aims to replace the dual ASA and DIN systems. For example, a film rating of ASA 100, 21 DIN becomes ISO 100/21°.

K

Kelvin A temperature scale which is used to indicate the colour of a light source. See *Colour Temperature.*

L

LEDs Light emitting diodes. These are electronic devices for displaying information. They are used for a number of photographic purposes, including the indication of under- or over-exposure, or the selected aperture/shutter speed combination.

Lens hood (shade) A conical piece of metal, plastic or rubber which is clamped or screwed on to the front of a lens. Its purpose is to prevent bright light sources, such as the sun, which are outside the lens field of view from striking the lens directly and degrading the image by reducing contrast (flare).

Long focus lens Commonly used slang for 'long focal length lens', which means any lens with a greater focal length than a standard lens, for example, 85mm, 135mm and 300mm lenses on a 35mm camera.

M

Mirror lens Any lens which incorporates mirrors instead of conventional glass (or plastic) lens.

M setting A flash socket found on many cameras which synchronizes the shutter to fire at the optimum moment when using flashbulbs.

N

Normal lens A phrase sometimes used to describe a 'standard' lens—the lens most often used, and considered by most photographers and camera manufacturers as the one which gives an image most closely resembling normal eye vision. The normal lens for 35mm cameras has a focal length of around 50mm.

P

Pentaprism An optical device, used on most 35mm SLR cameras, to present the focusing screen image right way round and upright.

Photoflood An over-run (subjected to a higher voltage than the bulb is designed for) which gives a bright light having a colour temperature of 3400K.

Polarized light Light which vibrates in only one plane as opposed to non-polarized light which vibrates in many planes.

Polarizing filter A polarizing (or pola) filter, depending on its orientation, absorbs polarized light. It can be used to reduce reflections from surfaces such as water, roads, glass, and also to darken the sky in colour photographs.

R

Reciprocity law failure Failure of the reciprocity law (which states: exposure = image brightness at the focal plane x shutter speed) manifests itself in loss of sensitivity of the film emulsion and occurs when exposure times are either long or very short. The point of departure from the law depends on the particular film, but for most camera films it occurs outside the range 1/2-1/1000 second, when extra exposure is needed to avoid under-exposure.

Red eye The phenomena of red eyes can occur when taking colour portraits by flashlight. They are avoided by moving the flashgun further away from the camera.

Reflected light reading A light meter reading taken by pointing the meter at the subject. It measures the light being reflected from the subject and the actual reading is obviously influenced by the nature of the subject.

Index

Reflector Any surface which is used to reflect light towards the subject, and especially into shadow areas.

S

Selective focus The technique of choosing a particular part of a scene to focus on. The aperture setting determines whether this selected portion of the scene alone is in focus or whether it is simply the centre of a zone of sharp focus.

Shutter The device which controls the duration of exposure.

Shutter priority See *Automatic exposure*.

Single lens reflex (SLR) A camera which views the subject through the 'taking' lens via a mirror. Many SLRs also incorporate a *pentaprism*.

Skylight filter A filter which absorbs UV light, reducing excessive blueness in colour films and removing some distant haze. Use of the filter does not alter camera settings that is, filter factor x1.

Slave unit A light-sensitive device which triggers other flash sources when activated by the light from the camera-connected flash.

Standard lens See *Normal lens*.

Stopping down The act of reducing the lens aperture size ie, increasing the f-number. Stopping down increases the depth of field.

T

Teleconverter An optical device which is placed between the camera body and lens, and increases the magnification of the image.

Telephoto lens A long focal-length lens of special design to minimize its physical length. Most narrow-angle lenses are of telephoto design.

Transparency A colour or black-and-white positive image on film designed for projection. Also known as a slide.

Tungsten film Any film balanced for 3200K lighting. Most professional studio tungsten lighting is of 3200K colour quality.

Tungsten light A light source which produces light by passing electricity through a tungsten wire. Most domestic and much studio lighting uses tungsten lamps.

U

Ultra-violet radiation Invisible energy which is present in many light sources, especially daylight at high altitudes. UV energy, if it is not filtered, causes excessive blueness with colour films.

W

Wide-angle lens A short focal-length lens which records a wide angle of view. It is used for landscape studies and when working in confined spaces.

Z

Zoom lens Alternative name for a lens having a range of focal lengths. One zoom lens can replace several fixed focal-length lenses, but results are likely to be inferior.